Consuming the American Landscape

To the memory and spirit of Stanley Diamond

Consuming the American Landscape

photographs by
John Ganis

introduction
Robert Sobieszek
afterword
George F. Thompson
poems
Dr. Stanley Diamond

dewi lewis publishing

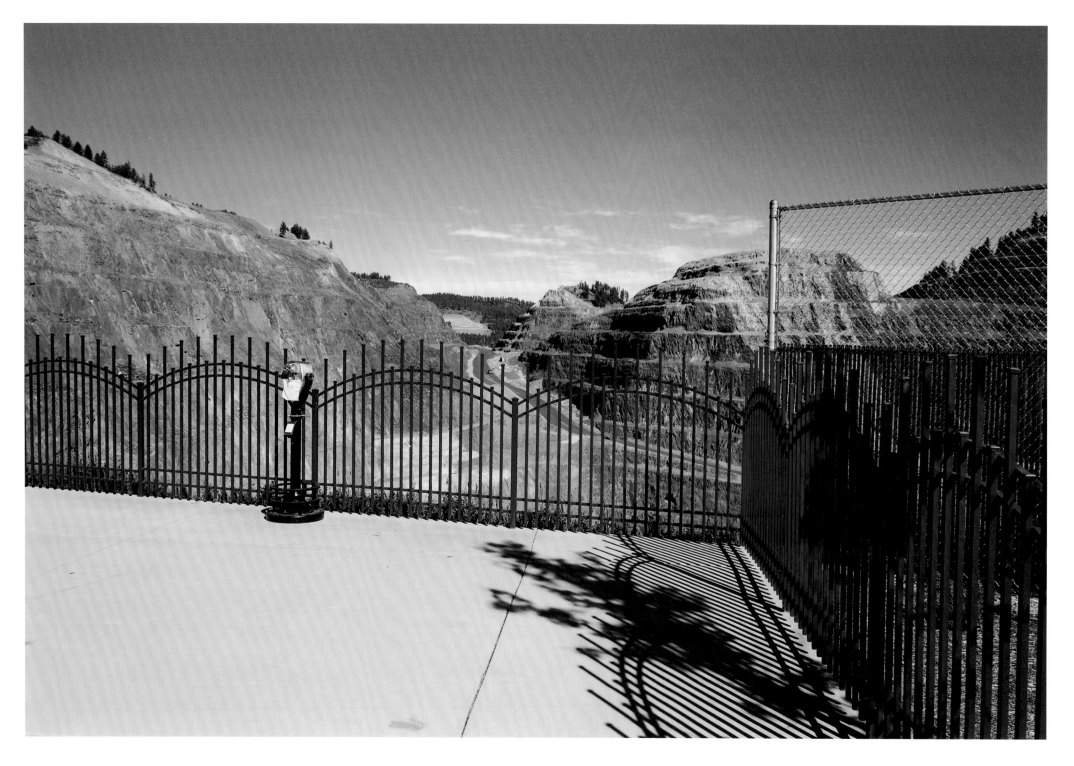

Open Cut Gold Mine, Lead, South Dakota

The Machine on the Verge: John Ganis and the new American Pastoral

Any landscape is composed not only of what lies before our eyes but what lies within our heads. [1]

With the last century clearly behind us, it has become increasingly obvious that the human conquest of nature is not the cause for celebration that it once was, nor can we in any way or with any complacency view wilderness as a phenomenon isolated from the effects of our culture. Our expanding presence in and impact on the land has become so pervasive that the boundaries between nature and culture have all but been utterly eradicated. The signs and marks of human culture are present no matter how far the reaches, how stratospheric the heights, or how abysmal the depths.

For more than 150 years, painters and photographers have depicted the American landscape, some with a passion often approaching the spiritual, others with a clinical rhetoric that nonetheless informs. As the landscape was built over, reworked, and controlled over the decades, the ways in which American artists have viewed the land and responded to it have varied dramatically. More than just in the details of circumstance and history they pictured – their artistic visions were informed, whether consciously or not, by constantly changing cultural and moral values concerning the land itself and the landscapes that portrayed it. The historic changes in our attitudes toward the

ideas of "nature" and "culture" are actually vested in artists' landscapes, but they also may be found metaphorically prompted by three very different sounds or noises – literary, anecdotal, and widely separated in time.

On July 27, 1844 the American writer Nathaniel Hawthorne was transcribing his impressions of pastoral nature while resting in the woods near Concord, Massachusetts when he was startled by the sudden blare of a train whistle. The discordant, harsh shriek was directly at odds with the Romantic's faith that nature was isolated from the 'noisy world' of industry and urban society. Once the momentary shriek ceased, however, Hawthorne wrote:

as our thoughts repose again, after this interruption, we find ourselves gazing up at the leaves, and comparing their different aspect, the beautiful diversity of green... [2]

For Hawthorne, the pastoral idyll was confidently and comfortably reclaimed as soon as the locomotive rounded the bend.

In British novelist E.M.Forster's dystopian story 'The Machine Stops' of 1928, a possible future scenario has all of society living

in vast urban sprawls beneath the surface of the earth, completely insulated from nature, and sustained by a system of massive machinery. Slowly, though, civilization begins to collapse, signalled at first by an intrusive, irritating, and audible change in the background sound of the machine. What was once soothing had become jarringly noisy, and the discomfort of this noise was soon augmented by moldy fruit, putrid bathing water, and foul air. Yet the citizenry eventually grew inured to these changes:

Time passed, and they resented the defects no longer. The defects had not been remedied, but the human tissues in that latter day had become so subservient that they readily adapted themselves to every caprice of the Machine. [3]

The inhabitants blindly continued with their increasingly despoiled lives, uncritically accepting the changes that were taking place around them. Forster's parable culminates in the complete collapse of the machine and of this particular futurist civilization.

A decade or so ago, hiking in the depths of New York's Adirondack State Park, environmentalist Bill McKibben was interrupted by the distant whine of a woodsman's chain saw cutting or trimming trees:

The sound of the chain saw doesn't blot out all the noises of the forest or drive the animals away, but it does drive away the feeling that you are in another, separate, timeless, wild sphere. Now that we have changed the most basic forces around us, the noise of that chain saw will always be in the woods... Even in the most remote wilderness, where the strictest laws forbid the felling of a single tree, the sound of that saw will be clear, and a walk in the woods will be changed – tainted – by its whine. [4]

In *The End of Nature* McKibben wrote that nature and culture have become so entropically merged that nature, as something separate from and unaffected by us, is impossible to consider or even imagine except nostalgically.

In the 19th century, photographers like William Henry Jackson and Carleton E. Watkins recorded the American landscape and, along with it, the expanding evidence of our place within it. The marks of human presence in the land, such as railway tracks, bridges, frontier towns, mining sites, and other tokens of progress and industrial growth were often uncritically portrayed by these camera artists as part of the natural order of things and even celebrated for their harmony with the land. In 1870, the explorer Nathaniel P. Langford even argued that the Yellowstone valley;

possesses adaptabilities for the highest display of artificial culture, amid the greatest wonders of Nature that the world affords... not many years can elapse before the march of civil improvement will reclaim this delightful solitude, and garnish it with all the attractions of cultivated taste and refinement. [5]

Hawthorne's locomotive and the attending civilization that

accompanied it were eagerly anticipated for developers like Langford.

Perceiving an increasingly threatened nature, many 20th century photographers sought to depict the wilderness in pristine isolation from human incursion. Nature, in the work of such photographers as Ansel Adams and Eliot Porter, was seen as something completely alien to civilization, as something to be preserved, and sequestered from human reach or at least its visible signs. Roads, buildings, jet contrails, telephone lines, and even human spectators were customarily treated as violations of a sublime wildness and excluded from their scenery.

Each of these two photographic traditions celebrated the land in its own way, either as a garden to be harvested or a conservatory in dire need of preservation. If Nathaniel Langford dreamt of cultivating the Yellowstone in 1870, by 1960 Ansel Adams could only imagine reversing the process and bringing Yosemite Valley back to its primitive state:

We may resent the intrusion of urban superficialities... but we can also respond to the challenge to re-create, to protect, to re-interpret the enduring essence of Yosemite, to re-establish it as a sanctuary from the turmoil of the time. [6]

In the late 1960s and early 1970s, however, a radically different tradition of landscape photography appeared in the work of such artists as Robert Adams and Lewis Baltz. These photographers of the so-called "New Topographics" showed us an essentially "man-altered" landscape, so overbuilt with motels, mobile-home parks, suburban housing tracts, telephone cables, and industrial parks that nature, as such, was all but completely removed from the picture.

Nevertheless, portraying nature in pure isolation and documenting the contemporary proliferation of man-made vistas are paradoxically comparable, for both acts of photographic depiction focus on the distinct separation of human activity from unadulterated wilderness. Whether the photographers pictorially stress impossible exclusion or more probable intrusion, their shared cultural bias is the firm belief that culture and nature are still mutually exclusive. Like the discrete and balanced separation of nature and culture in Forster's short story, the two are essentially independent in both concept and fact.

Over the past two decades or so, a number of American photographers have turned a somewhat different critical, and even at times political, eye on the landscape as it appears changed, marked, used, and misused by us and our expanding culture. With images of striking beauty and visual power, these photographers force us to confront the not always pleasant facts of our integration within nature. In an age when the effects of air and water pollution, acid rain, deteriorating industrial infrastructures, toxic-waste dumps, strip mining, a shrinking ozone layer, runaway population growth, and even tourism have put the very ideas of wilderness and wildness at risk, the images created by these photographers clearly suggest that we are not independent

of the land but an integral part of nature. Like McKibben's whining, distant chain saw, there is nowhere to go to escape ourselves.

Nathaniel Langford might have wanted to bring civil improvements to Yellowstone in the nineteenth century, and four decades ago Ansel Adams may have wanted to re-establish Yosemite as a natural sanctuary, but in 1973 the "earth artist" Robert Smithson expressed an entirely different conviction:

Today, Yosemite is more like an urbanized wilderness with its electrical outlets for campers, and its clothes lines hung between the pines. There is not much room for contemplation in solitude... In many ways the more humble or even degraded sites left in the wake of mining operations offer more of a challenge to art, and a greater possibility for being in solitude. [7]

Like their 19th century counterparts, many contemporary landscape photographers have begun to again concentrate on depicting human enterprise as within and not apart from nature. The important difference, however, rests in the questions this new work poses concerning our perception of the landscape and what lines may or may not exist dividing nature from culture.

It has become a postmodern truism that all nature is experienced through the lens of culture. [8]

For the past seventeen years, Detroit-based photographer John Ganis has been documenting what he calls the "over-developed/under-respected lands" of the continental United States. [9]

In pictures that are broadly colorful, often lyrically seductive, and at times coolly ironic – Ganis questions the tensions that exist between photographic beauty and a not so attractive reality, while at the same time documenting those places where "the man-made, the cultural, and the natural are entropically merged." [10]

The subjects of Ganis's images are for the most part flagrantly clear – abandoned wrecks, desolate strip mines, clear-cut forests, industrial parks, landfill sites, and the flattening of terrains for housing developments – and just as flagrantly disturbing. His imagery is a thesaurus of the varieties of "civilized" incursions into the wildness of nature, a picturesque survey of hundreds of "minor" horrors discovered in a serene and well-lighted out-of-doors, a colorful charting of our debris-strewn topographies, and a cogent report on our abdication of any reverence towards the land.

Elements of both the *picturesque* and the *rustic* serve in Ganis's work to mediate between the *idyllic* and the *apocalyptic*, suggesting, ironically perhaps, that such scenes may yet be accompanied by romantic associations. When viewing the textile mills of North Adams, Massachusetts more than one and a half centuries ago, Nathaniel Hawthorne saw "a sort of picturesqueness in finding these factories, supremely artificial establishments, in the midst of such wild scenery." [11]

In Ganis's landscapes, it is the wild scenery, or what remains of it, that seems to be the picturesque quotient. His images are not topographic studies as much as they are traditional romantic

"rustic landscapes." Where the intent of traditional topographic images had been to portray a celebrated site or view, the rustic landscape strives to meditatively "evoke the countryside and rural life." [12]

Thus, we find in Ganis's photographs a generic description of our contemporary countryside. Dirt-bike trails trace a hilly topography in Southern California. An industrial pipeline quietly slithers beneath an Alaskan meadowland. A rainbow gracefully arcs over barren mine tailings in Utah. Where once farmers cleared land for crops and grazing, vegetation is now burnt and agricultural fields levelled for sale and development. E.P.A. remediation sites host a spectrum of strident colors unseen in untampered nature. A couple of forlorn cholla plants stand witness to the barren devastation of panoramic terraforming within Arizona's Sonoran desert.

In particular, Ganis's work is really about the edge, the margin that separates the uncultivated from the over-farmed, the pastoral garden from the bleak wasteland, the "natural" from the cultured, the past from the present. This edge is seen in the ever expanding border of a Christo-like wrapped, earthen levee containing a Michigan landfill, the lone cabin sited between the edge of some burnt-sienna pools of toxic water and the edge of a verdant forest, the undifferentiated edge of a golfing green set in the parched Arizona desert, the row of young sumacs bordering a bulldozed site for a Pennsylvania shopping center. In one particularly poignant image, the back yards of nearly undif-ferentiated tract houses, either recently completed or still under construction, threaten to squeeze a small gully of wild flowers, thistles, and a few trees into a negligible token of what had been farm lands and before that the great forests of the Midwest. Ganis confronts, records, and verges, as it were, upon some of the few verges that still remain.

John Ganis did not begin photographing these landscapes with any agenda in mind. "As an artist," he wrote, "I did not start out photographing the land with a political axe to grind. I came to my subject with an 'empty cup' and the more I saw, the more I worked, [the more] I came to develop a viewpoint of environmental concern." [13]

In his approach to what has become a personal visual cataloguing of small and large environmental impacts, Ganis has searched for ways in which we may deconstruct our still unspoken trust in the progress of "civilization". "This is accomplished," he believes, "by the rediscovery of reverence for the earth and its infinite display of diversity and life. To marvel at nature's beauty, even in the face of environmental distress, is of course ultimately ironic but not cynical or insincere." [14]

Ganis's pictorial vocabulary includes a measure of ironic wit that rescues his work from being unredeemingly depressive. In one of his early pictures, two cement moose are discovered near a stream in Arkansas, like an insane metaphor of how to cope with endangered species. In another image, a tower of a water slide

crowns a barren pile of earth in Texas, like the bridge of some sort of post-apocalyptic submarine beached in a future desert. In another, the containing mound of a waste disposal site in Ohio, is covered with blue and white striped plastic that in turn is held down by dozens of tires, like some vestige of a recently abandoned traveling circus. In a later image, an under-construction housing development in Southern California is depicted from a hilltop nestled in a quiet valley between rolling hills; in the foreground twin tire ruts of some presumably recreational vehicle lead to and disappear over the edge of the hill – seen as some sort of wry allusion to the suicide run of the machine in the garden.

"In the place of the old nature," wrote McKibben in 1989, "rears up a new 'nature' of our own devising." [15] John Ganis's photographs are precisely about the new "nature" that we are creating with a kind of "fine disregard" for what we were entrusted with. One of the most disconcerting and haunting images this photographer has made is of the outer perimeter of a landfill somewhere in Oklahoma. Dry, parched reddened earth has been bulldozed and redistributed over a water source and amid a grove of trees. The small creek in the image has managed to erode some of the fill in a tenacious (but futile?) attempt to surface again. The trees have been surrounded by the earth to a level well above the crowns of their roots, leaving them to eventually suffocate and become part of yet another fill. Beyond, the crest of the landfill's red earth presents a lifeless horizon, beyond which we may only imagine an infinite expanse of the same barrenness.

The narrator of Walker Percy's *Love in the Ruins* of 1971, writing amid a suburban landscape of deserted shopping plazas and broken motels at a "time near the end of the world," asked the correct question:

Is it that God has at last removed his blessing from the U.S.A. and what we feel now is just the clank of the old historical machinery, the sudden jerking ahead of the roller-coaster cars as the chain catches hold and carries us back into history with its ordinary catastrophes, carries us out and up toward the brink from that felicitous and privileged siding where even unbelievers admitted that if it was not God who blessed the U.S.A., then at least some great good luck had befallen us, and that now the blessing or the luck is over, the machinery clanks, the chain catches hold, and the cars jerk forward? [16]

Ultimately, we can only question the nature of this new "nature", and suspect that our luck may indeed be over. Or, perhaps, just somehow, with nanotechnology and genetics, the machinery does not stop, it clanks, and we just may be jerked forward onto the verge that we once thought was ours.

Robert A. Sobieszek

1. D. W. Meinig, 'The Beholding Eye', in *The Interpretation of Ordinary Landscapes: Geographical Essays*, ed. D. W. Meinig (New York: Oxford University Press, 1979), 34. Portions of this essay were written in conjunction with the exhibition 'The New American Pastoral: Landscape Photography In The Age Of Questioning,' which I organized for the George Eastman House in 1989. I would like to thank that institution for permission to republish those portions.

2. Cited in Leo Marx, *The Machine in the Garden* (New York: Oxford University Press, 1967), 13-14.

3. E. M. Forster, 'The Machine Stops' (1928), reprinted in Harry Harrison (ed), *The Light Fantastic: Science Fiction Classics from the Mainstream* (New York: Charles Scribner's Sons, 1971), 147-48.

4. Bill McKibben, *The End of Nature* (New York: Random House, 1989), 47-48.

5. N. P. Langford, *Diary of the Washburn Expedition to the Yellowstone and Firehole Rivers in the Year 1870*, (St. Paul, Minn., 1905), cited in Peter Bacon Hales, *William Henry Jackson and the Transformation of the American Landscape* (Philadelphia: Temple University Press, 1988), 96.

6. Ansel Adams, statement, 'Portfolio Three: Yosemite Valley' (San Francisco: Sierra Club, 1960), unp.

7. Robert Smithson, 'Frederick Law Olmsted and the Dialectical Landscape', in *Robert Smithson: The Collected Writings*, ed. by Jack Flam, (Berkeley: University of California Press, 1996), 166.

8. James Gorman, 'A Skier's Quest for Snow', *The New York Times* (December 28, 2001), E39.

9. John Ganis, letter to the author, July 24, 1990.

10. Lewis Baltz, interview, *Camera-Austria*, 11/12 (1983), 5.

11. *Nathanial Hawthorne, The American Notebooks*, ed. Randall Stewart (New Haven: Yale University Press, 1932), 34, cited in John F. Sears, *Sacred Places: American Tourist Attractions in the Nineteenth Century* (New York and Oxford: Oxford University Press, 1989), 196.

12. Ann Bermingham, *Landscape and Ideology: The English Rustic Tradition, 1740-1860* (Berkeley: University of California Press, 1986), 10.

13. John Ganis, letter to author, July 24, 1990.

14. John Ganis, unpublished artist's statement, 1991.

15. McKibben, *The End of Nature*, 96.

16. Walker Percy, *Love in the Ruins: The Adventures of a Bad Catholic at a Time Near the End of the World* (New York, Bard/Avon Books, 1981), 3-4.

Consuming the American Landscape

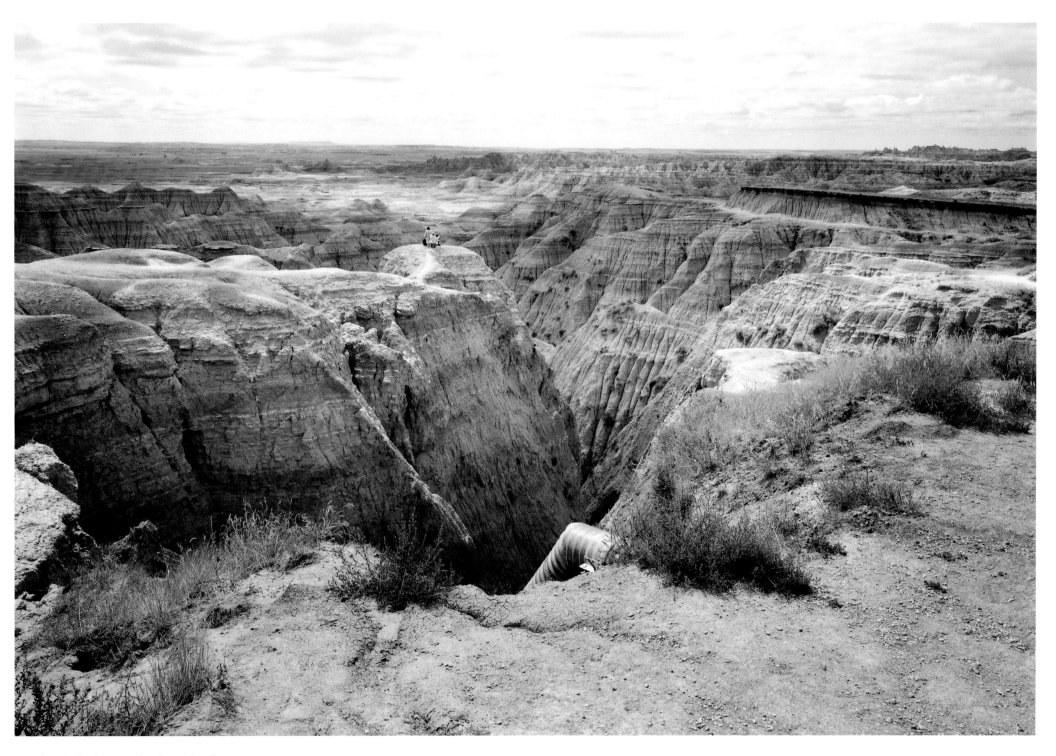

Family at Badlands National Park, South Dakota.

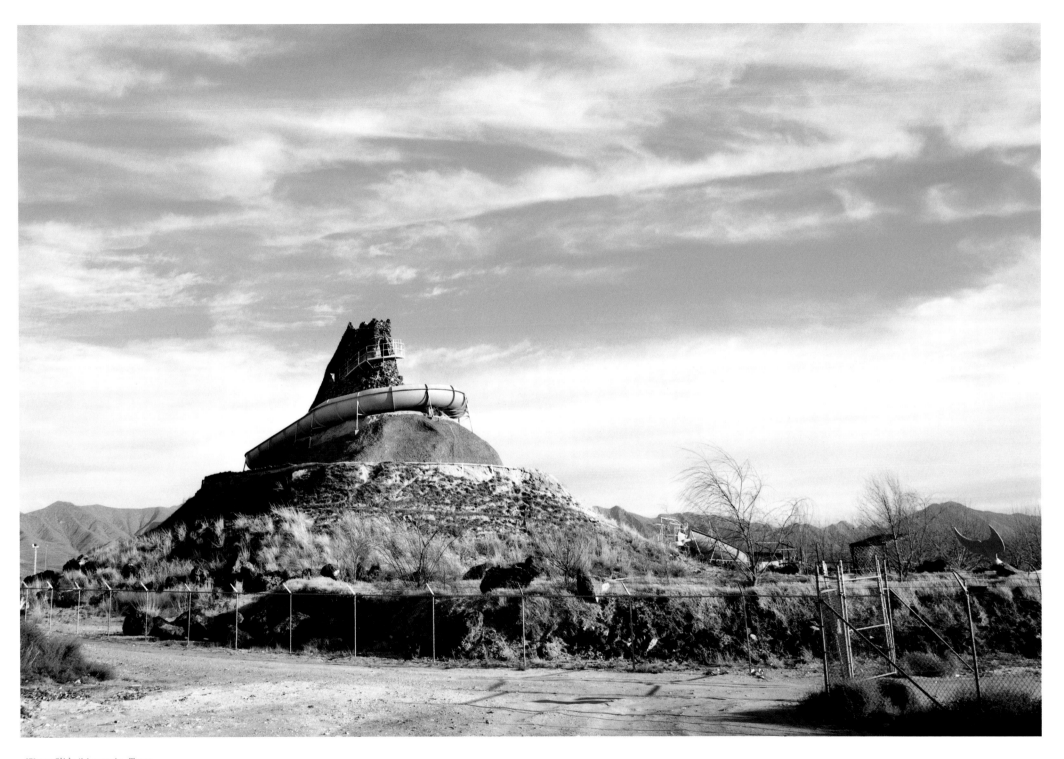

Water Slide/Mountain, Texas

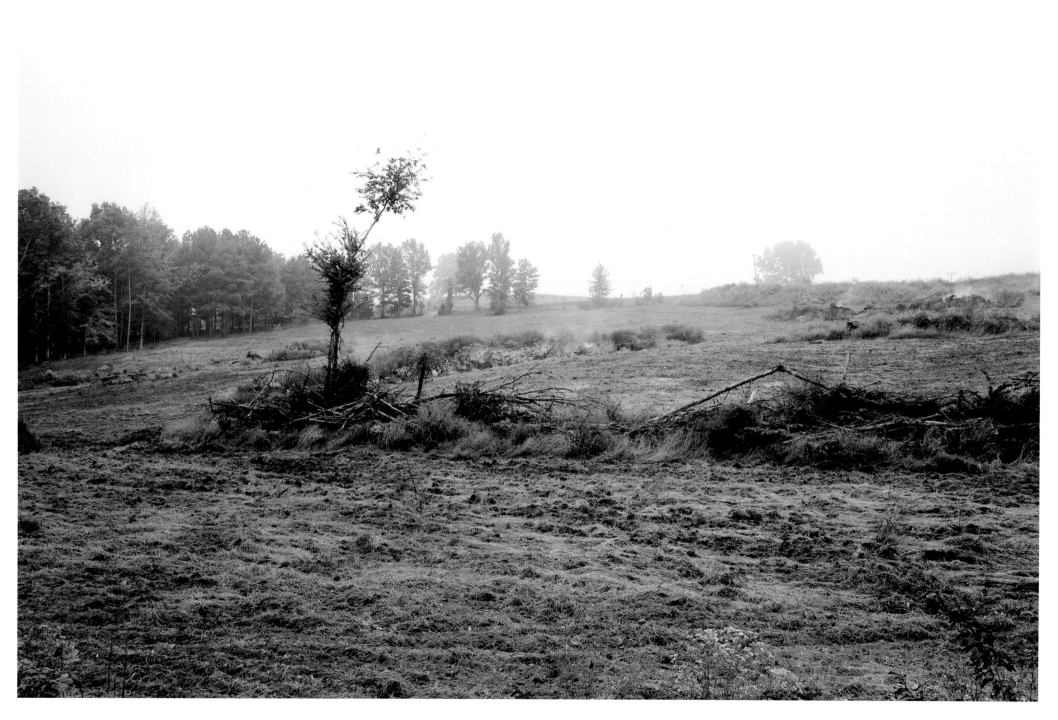

Clearing Land for Development, Arkansas

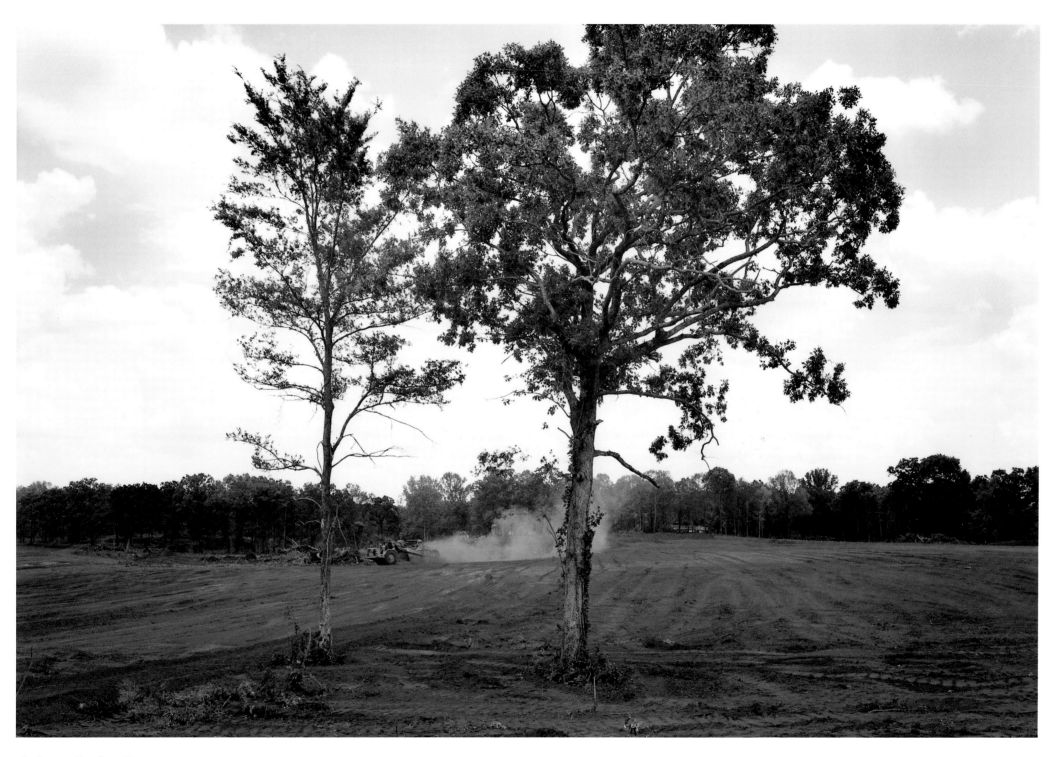

Earthmover, Texarkana, Texas

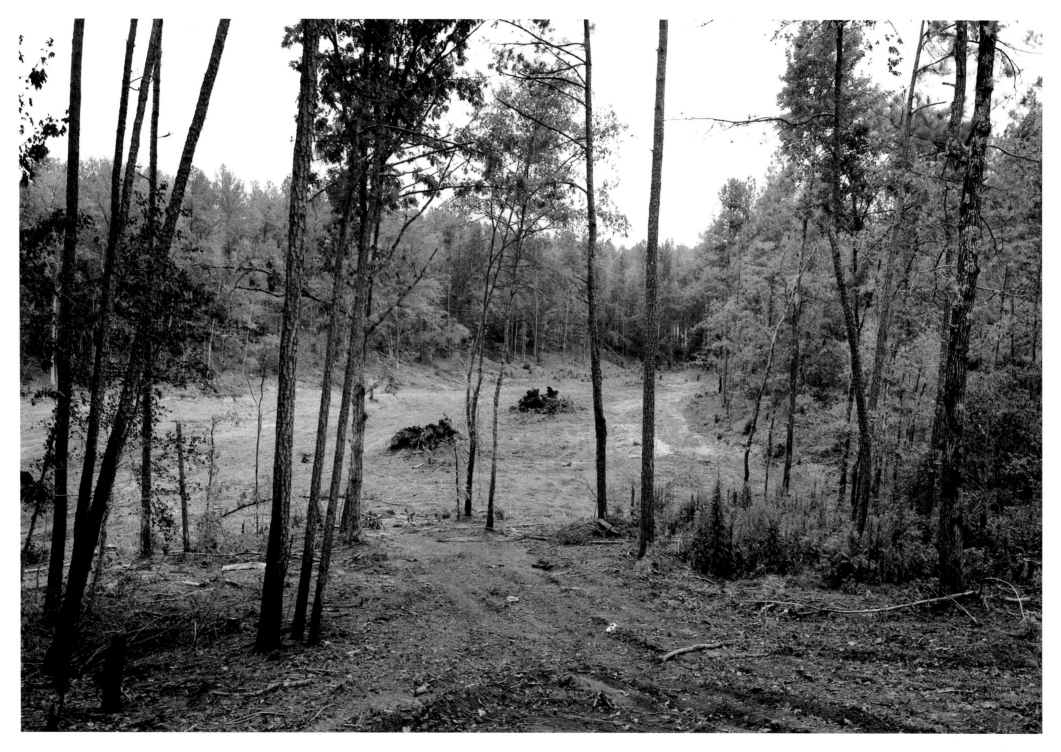

Subdivision Development, South Carolina

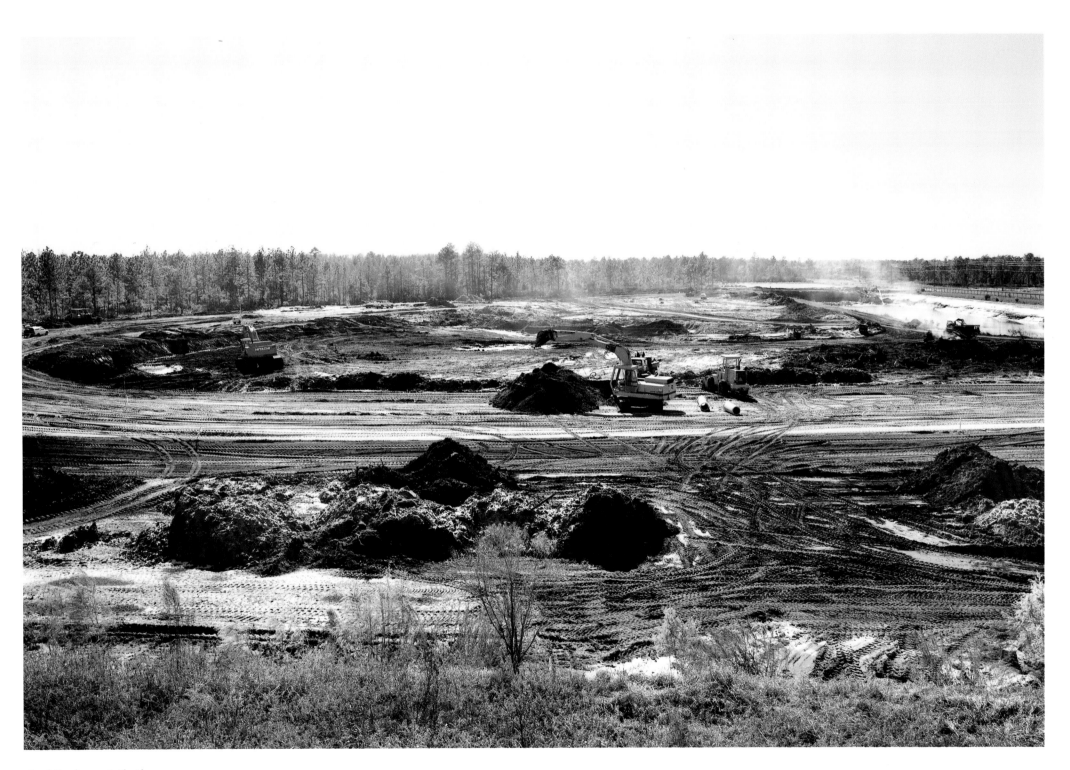

Land Development, Florida

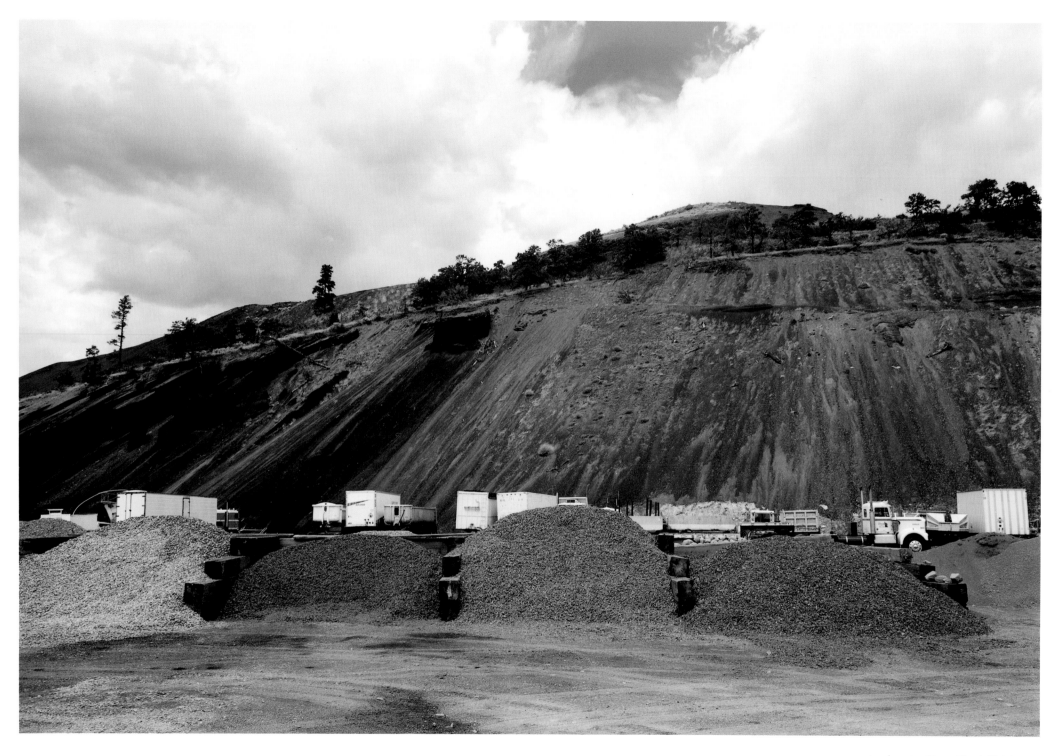

Landscaping Stone, Flagstaff, Arizona

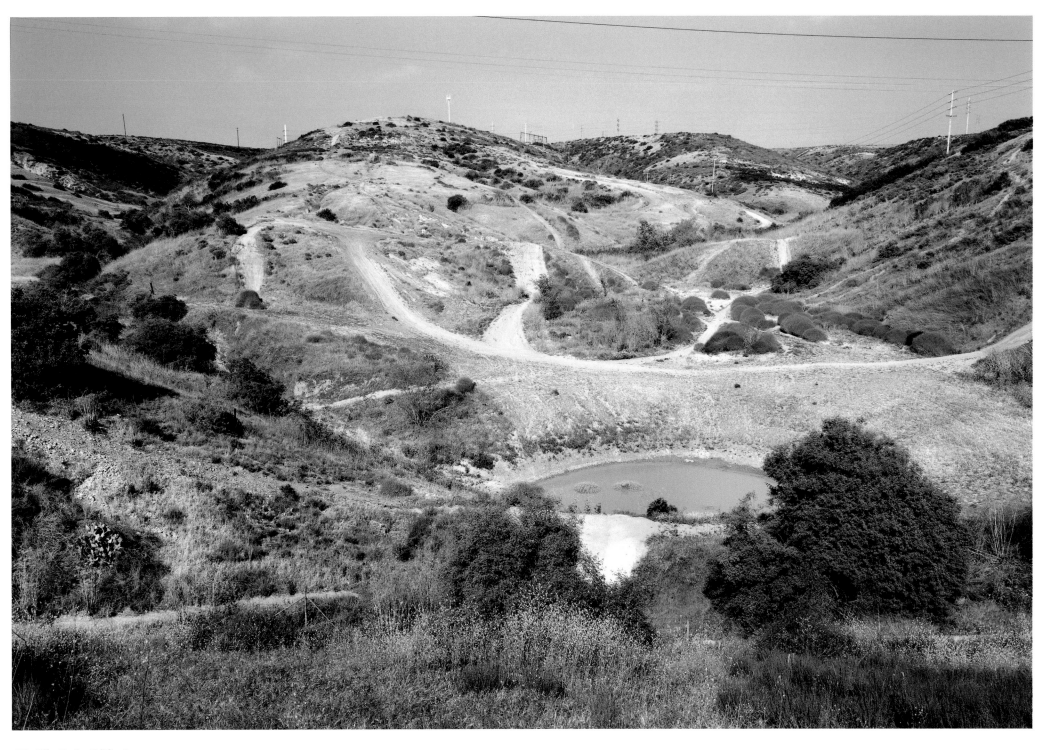

Dirt Bike Trails, California

The soil renews itself
To the point of extinction

Crumbling in wind
Rocks, no longer grow

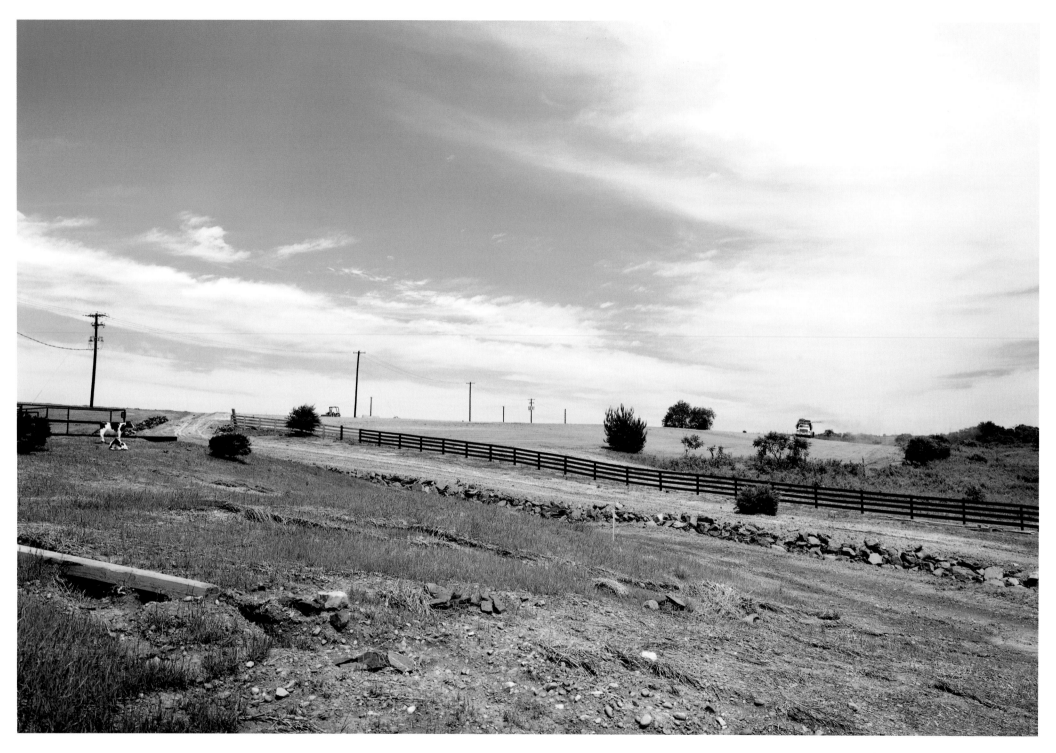

Plastic Cows, Buckhorn, Pennsylvania

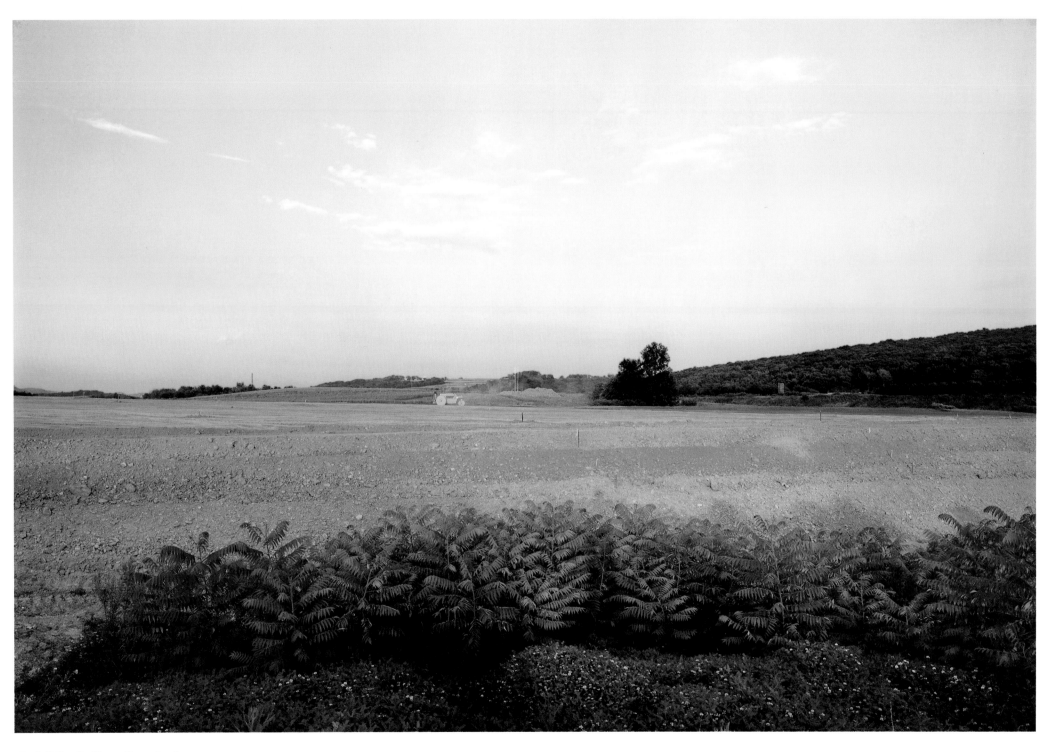

Earth Roller, Buckhorn, Pennsylvania

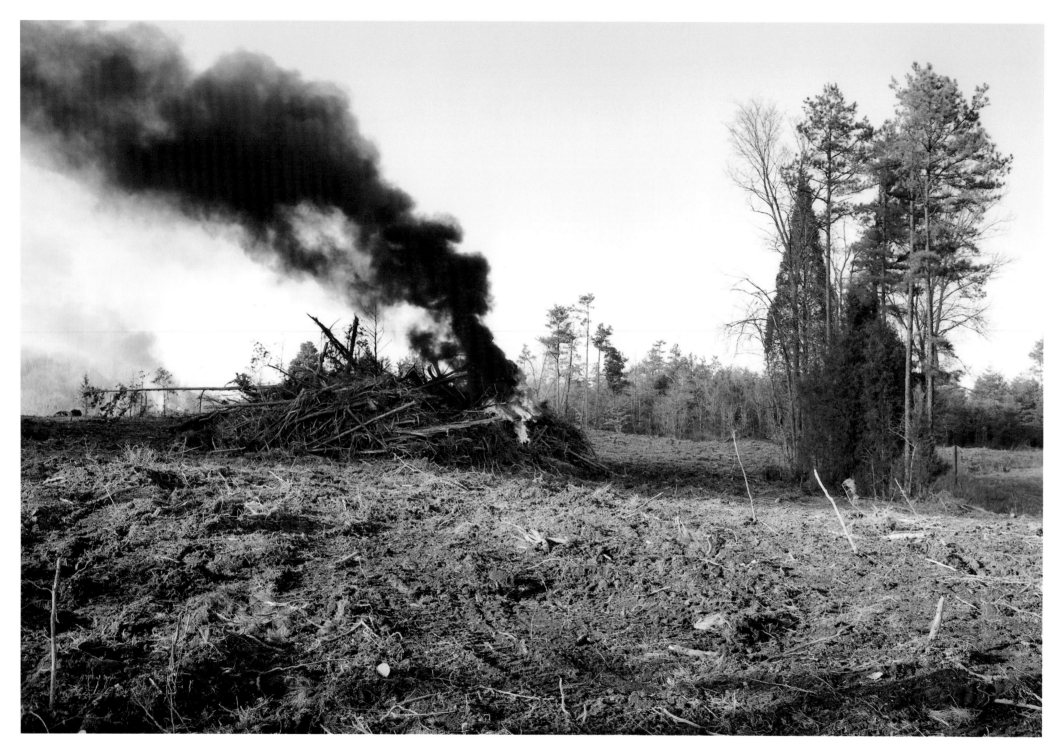

Burning Tires and Trees, Highway Construction, Tennessee

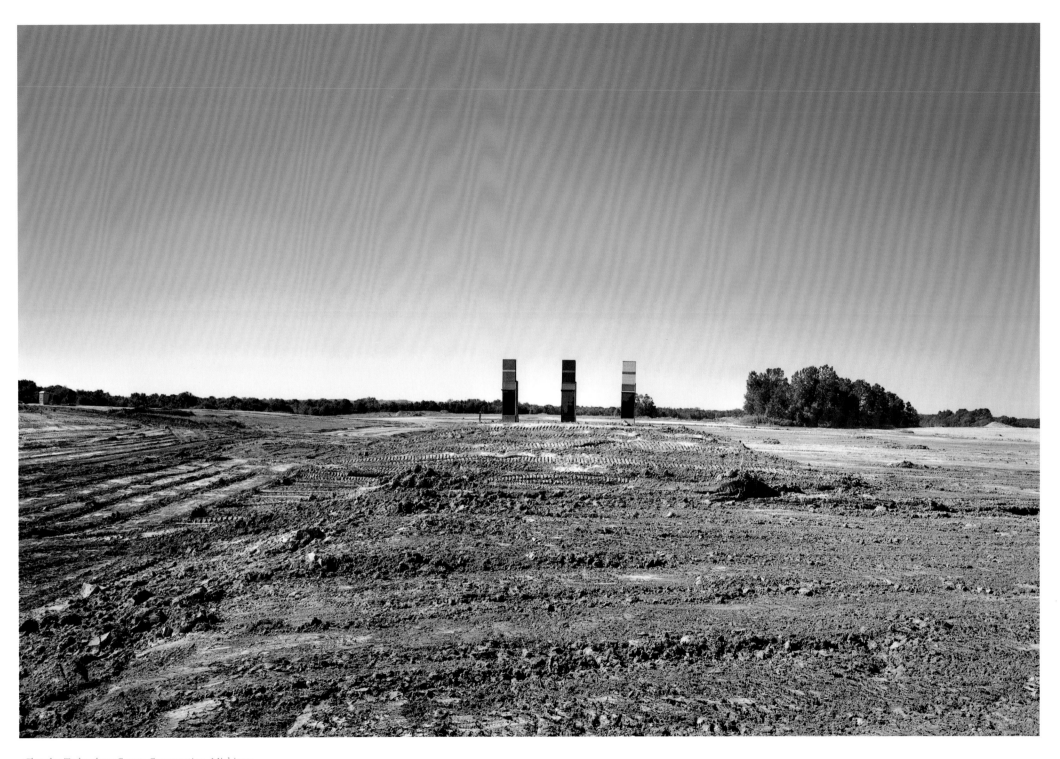

Chrysler Technology Center Construction, Michigan

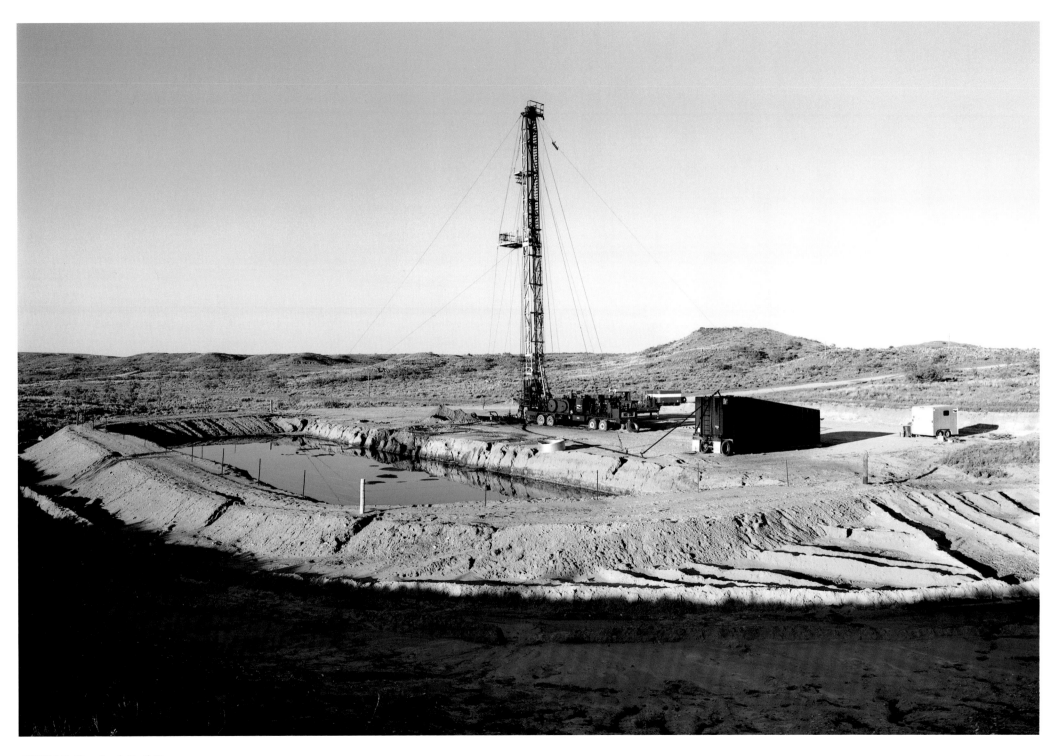

Oil Well Drilling Pond, North Texas

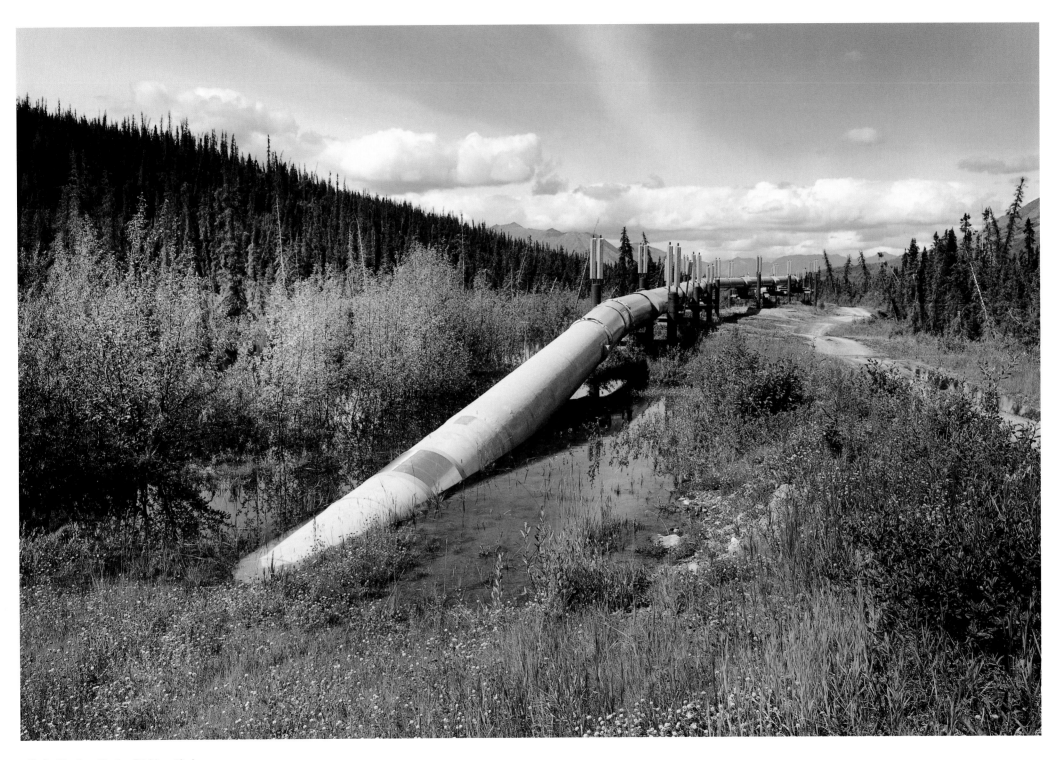

Alaska Pipeline, North of Valdez, Alaska

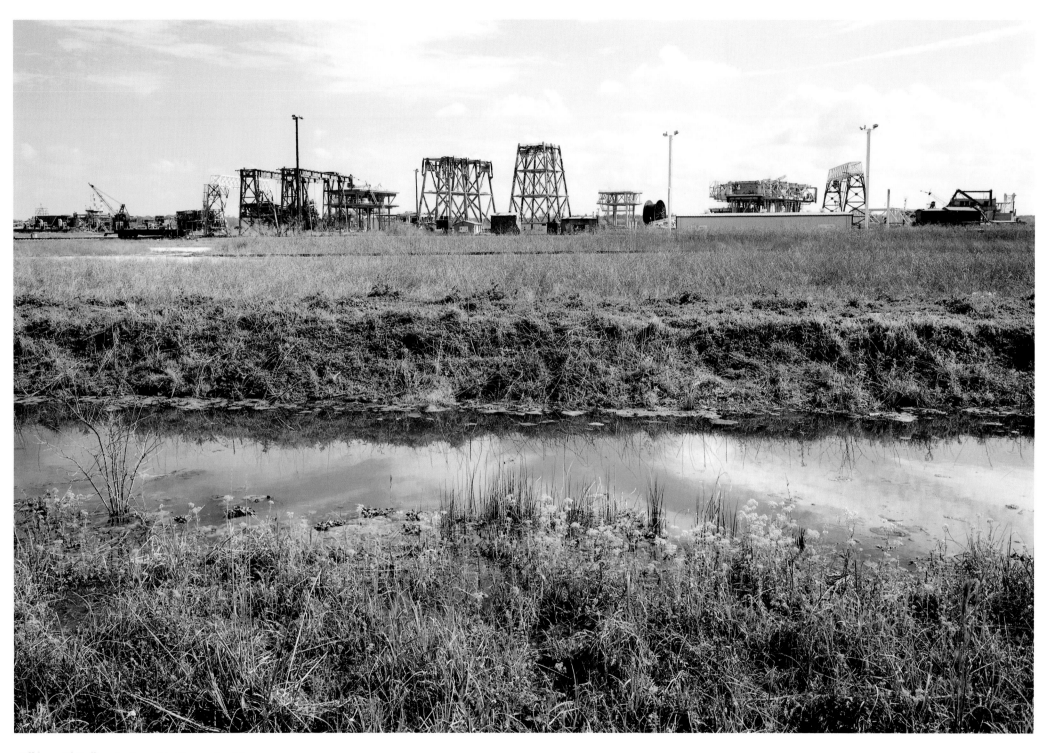

Offshore Oil Drilling Equipment in Storage, Louisiana

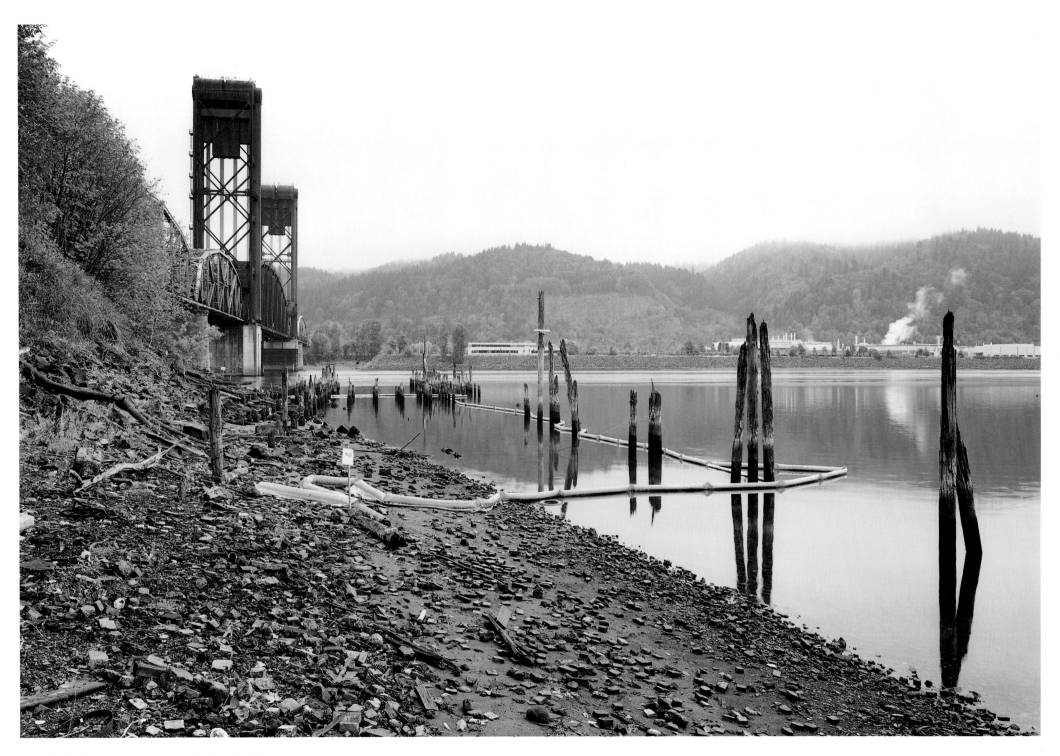

Superfund Cleanup Site, Willamette River, Portland, Oregon

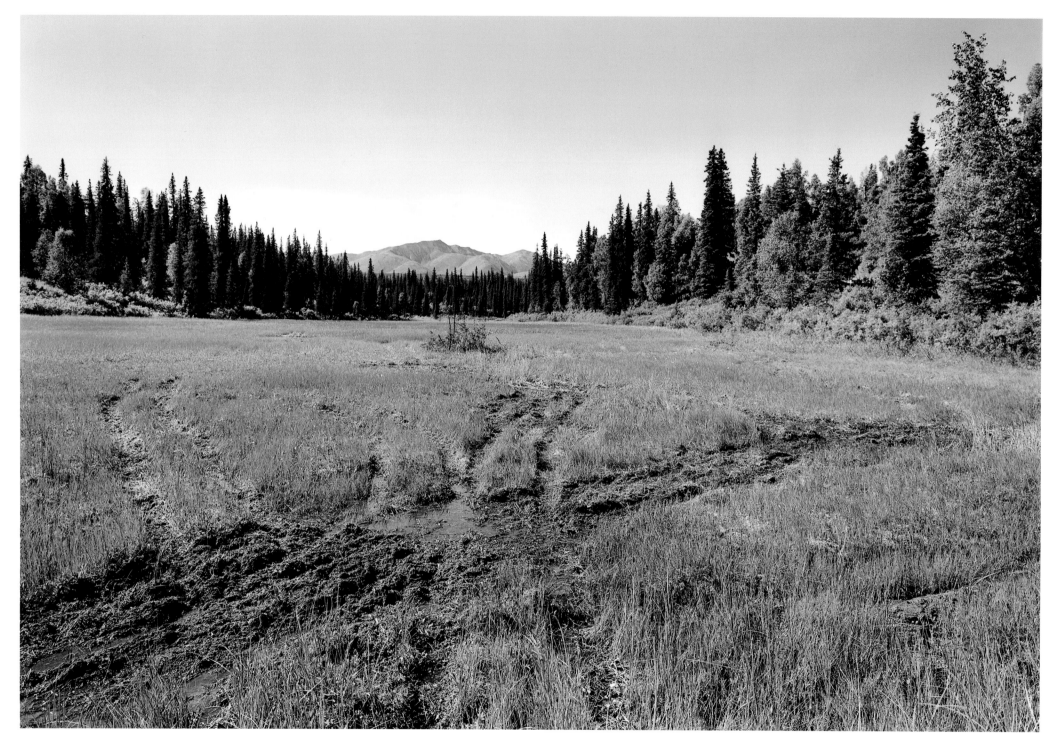

All Terrain Vehicle Damage, Peters Creek, Alaska

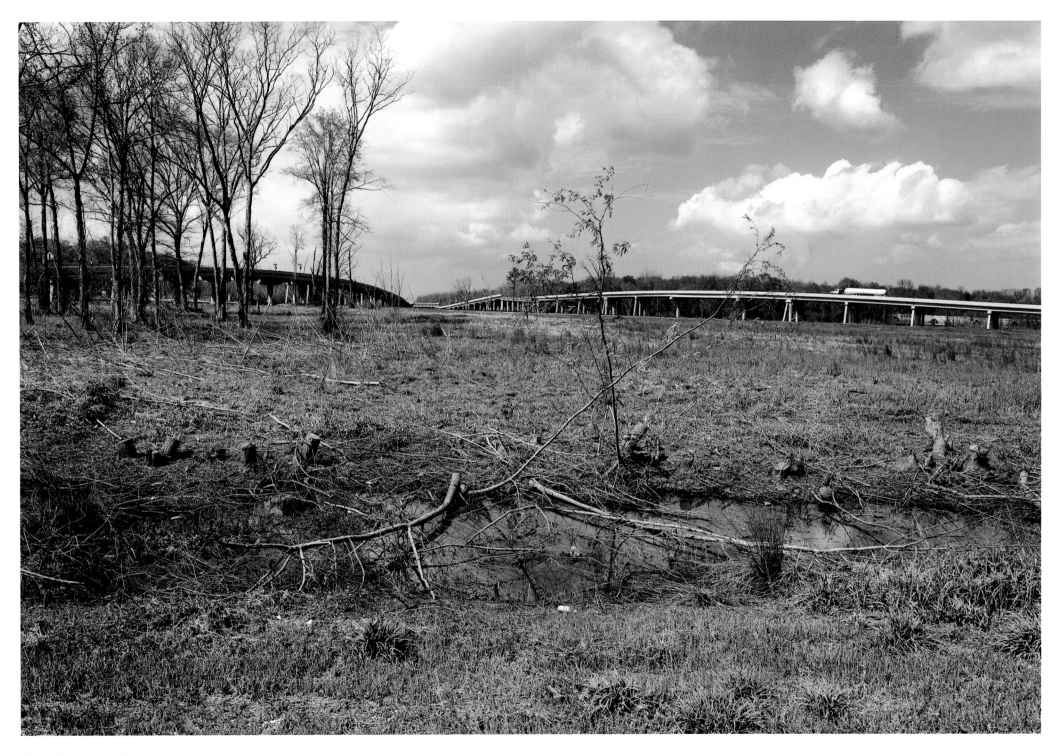

Bayou Overpass, Louisiana

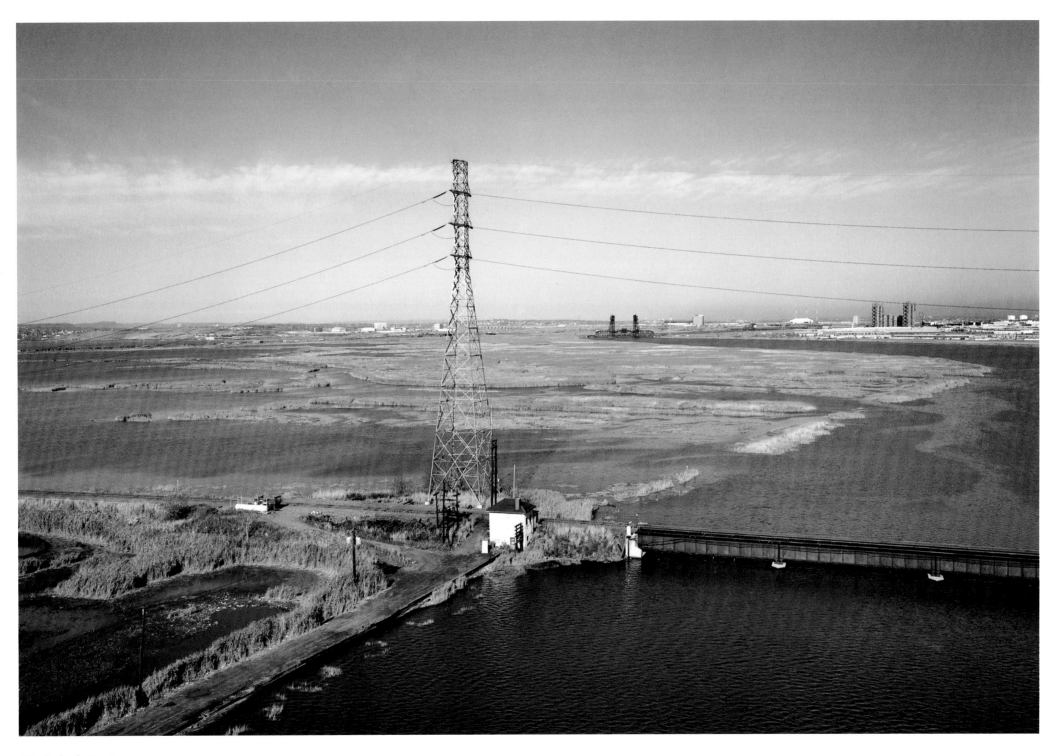

Meadowlands, New Jersey

A culture
Is its refuse
Here among the kitchen middens
And Indian mounds
Even archaeologists
See Earth
Returning to Earth
Ashes to ashes
Dust to dust
Bones, shards
Beads of leather
And shells
Fibers of baskets
And bows
Drums and flutes
Sinew and thong
Real enough to disappear

Into origins
And Overall
The imprint
Of aspiring wonder
The mythic mound
A holy relic
Of refuse
Immortal in spirit
Earth returning to Earth
Say the Elders
Now and forever

How unlike the objects
Merely objects
Therefore dead
That we discard
Artifacts of steel
Hard glass tubes
Concrete
Wave upon wave

An infinity of trash
Flushed and buried
Beneath the sea
In mines and quarries
Lakes and rivers
In the air we breathe
Fear is everywhere
Who can trust
What we eat or drink
Love or hate
What has been absolute
For forty-thousand years
The ground of being itself
The pact we make with infants
No longer holds
And over all
The imprint
Of killing machines
At which
Only the roach will one day wonder

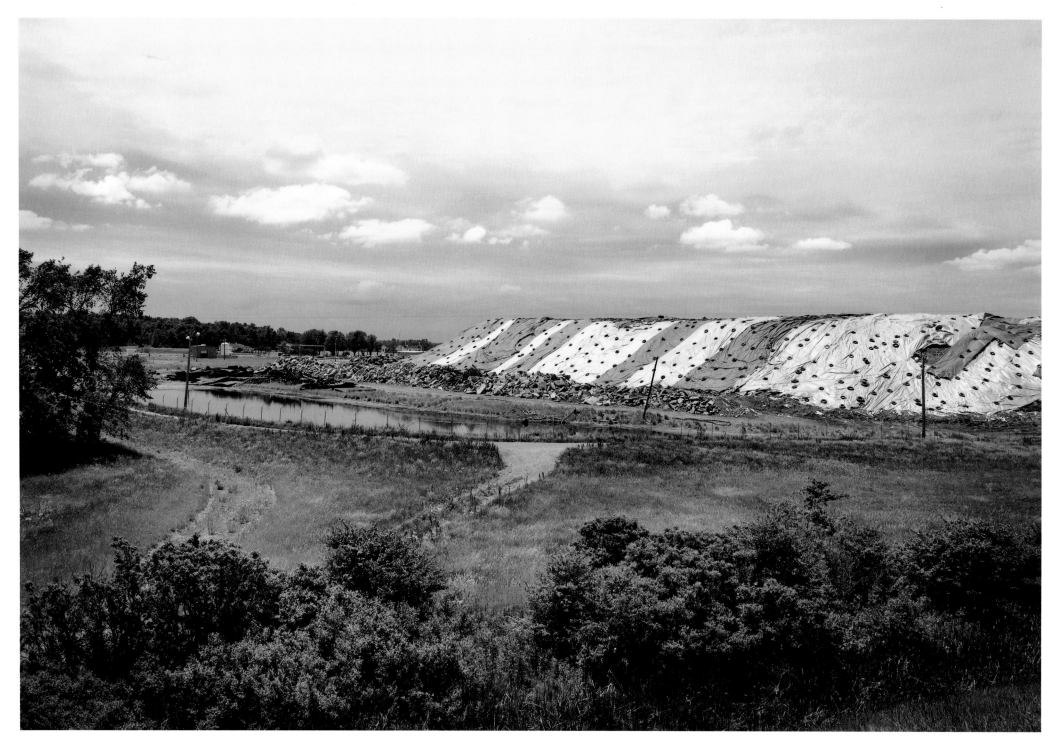

Waste Disposal Site, Ohio

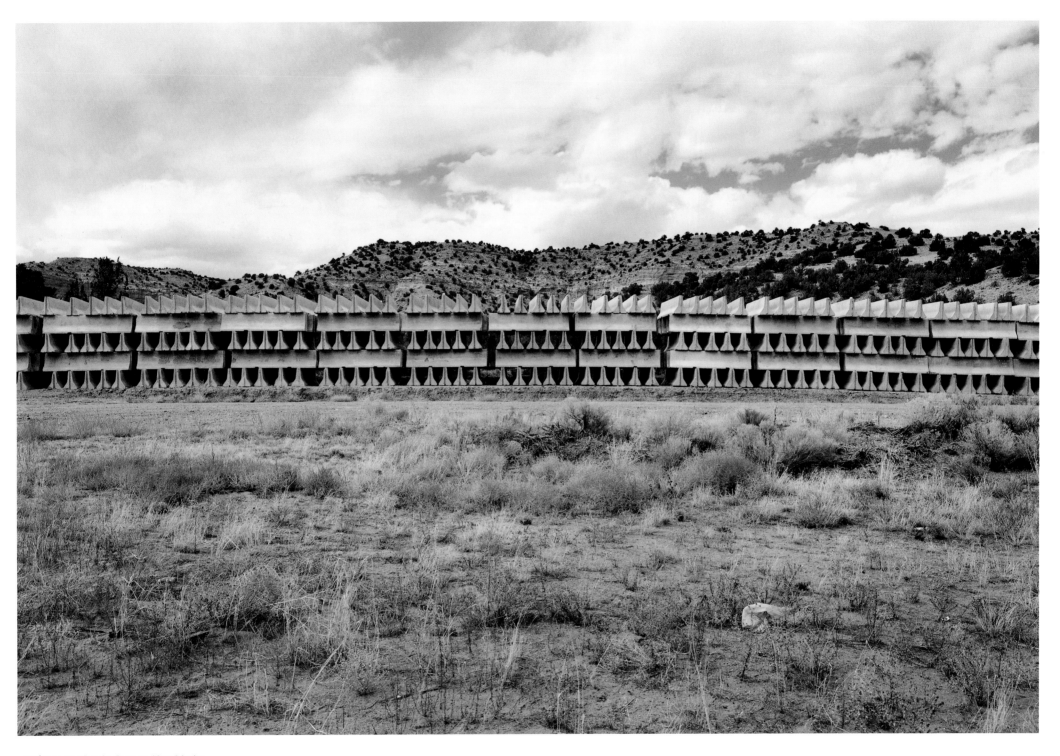

Highway Barriers in Storage, New Mexico

45

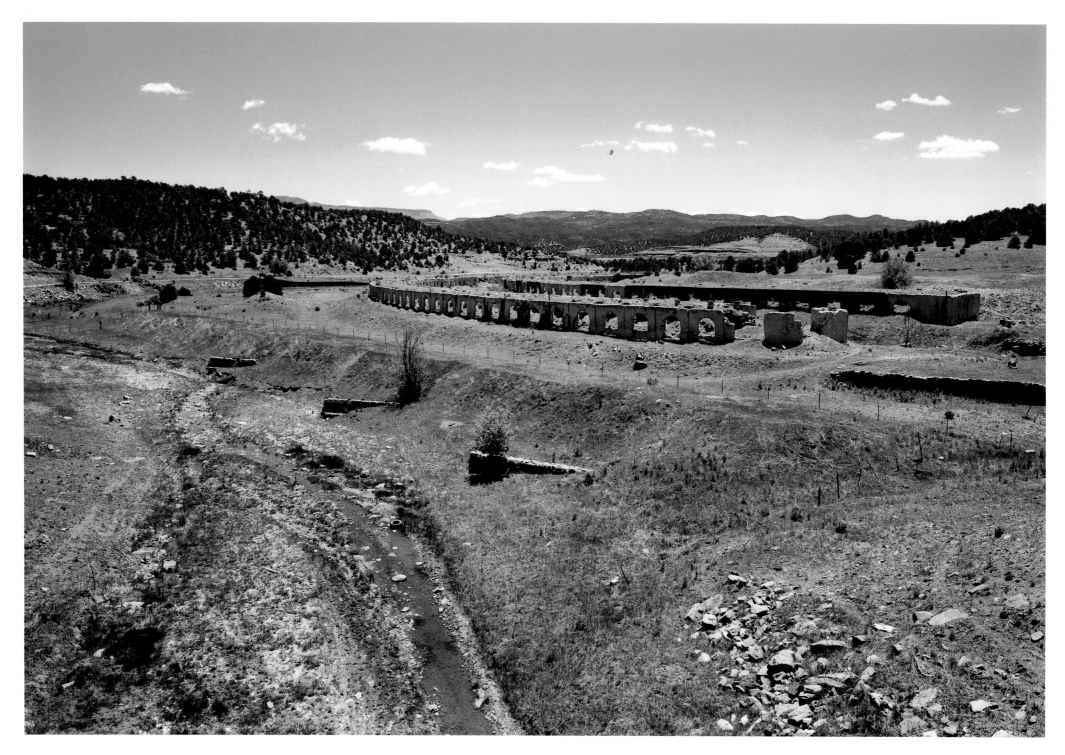

Coke Ovens, Trinidad, Colorado

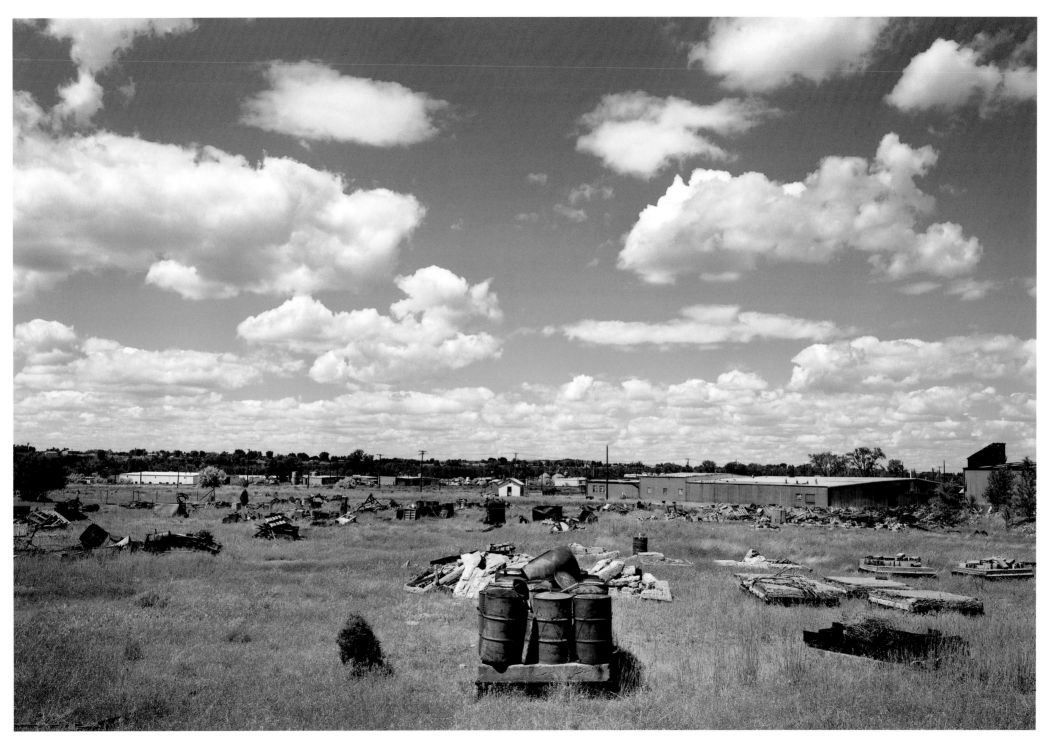

Discarded Debris, Montana

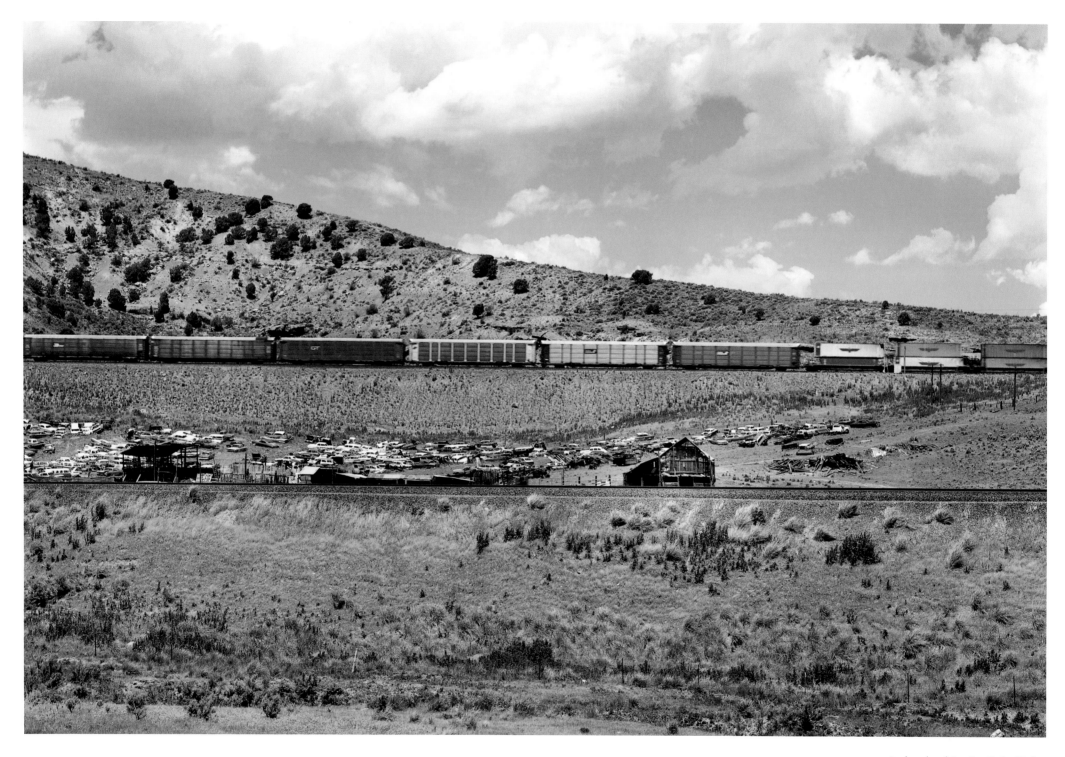

Junkyard and Passing Train, Utah

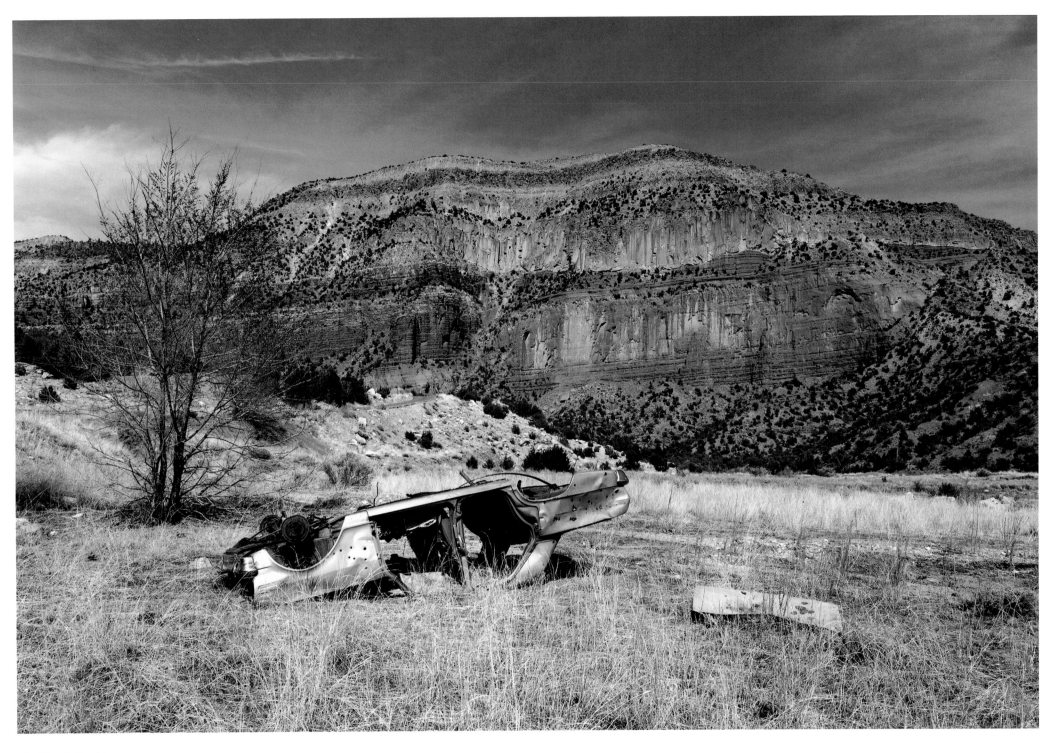

Car/Target, New Mexico

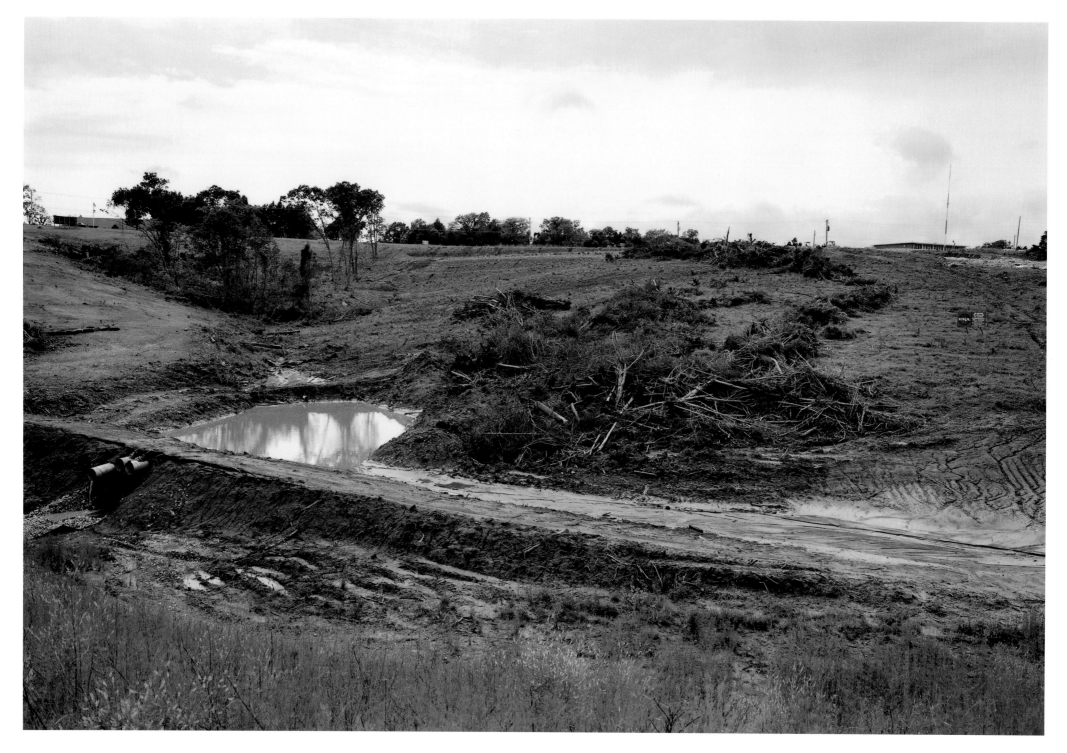

Land for Sale, Missouri

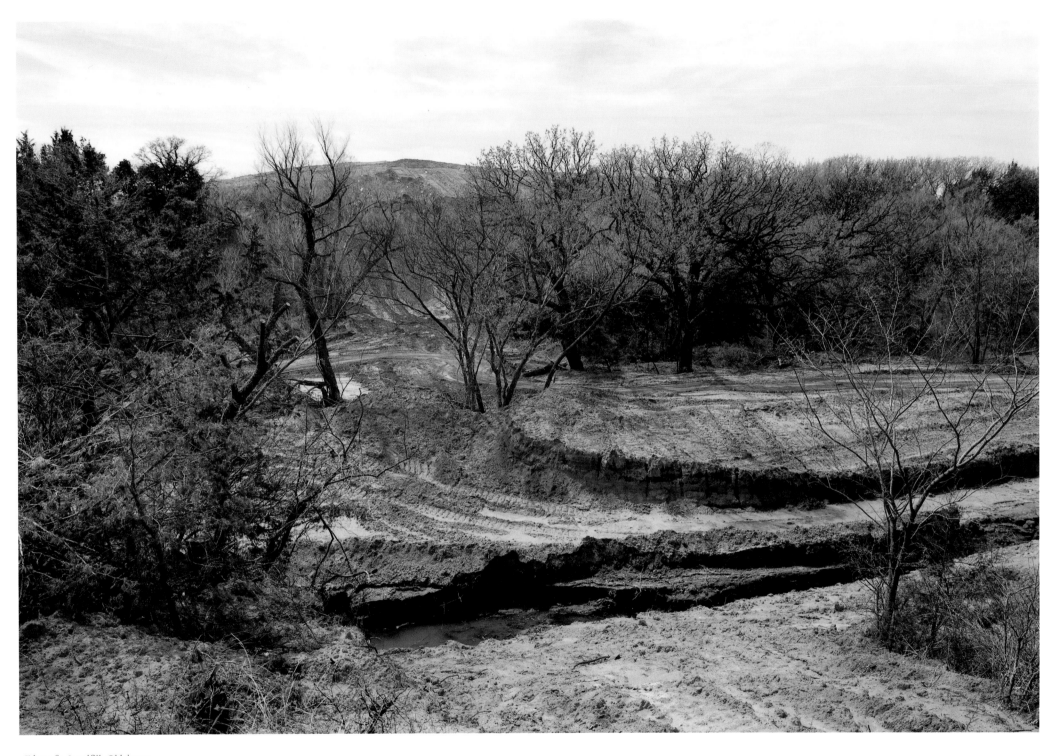

Edge of a Landfill, Oklahoma

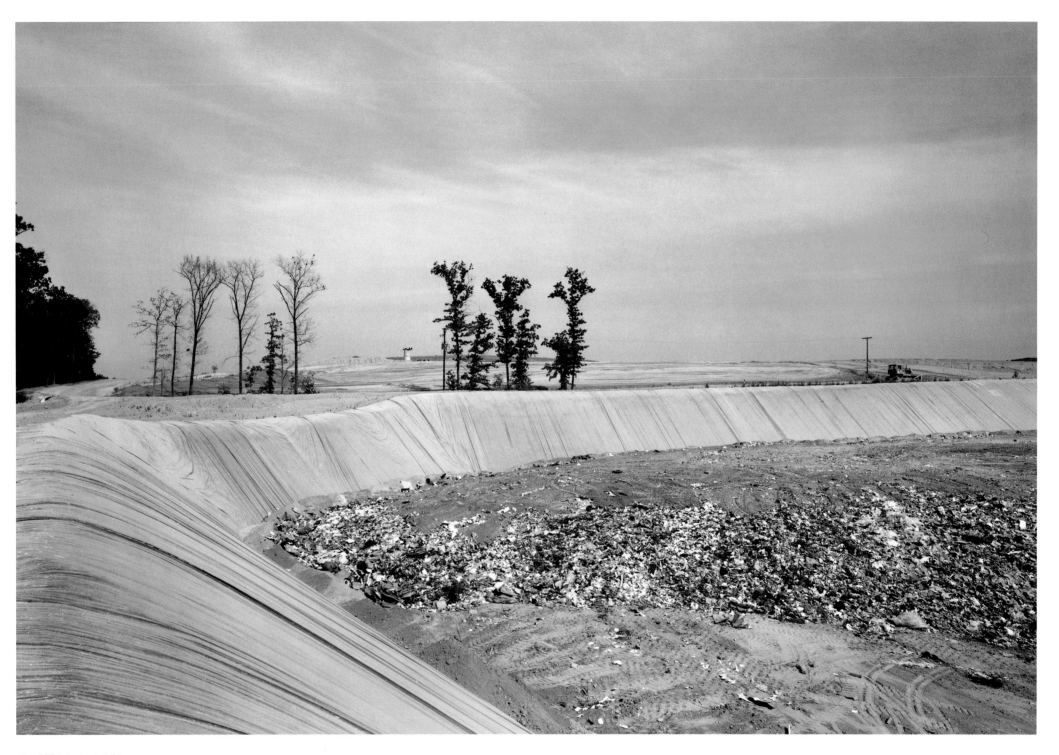

Landfill Interior, Michigan

In the beginning the mine
was on the edge of town

In the end, the town
was on the edge of
the mine

The tailings ran like lava
aborting the mountain

People fled to paper cities
without money

Without work, without hope

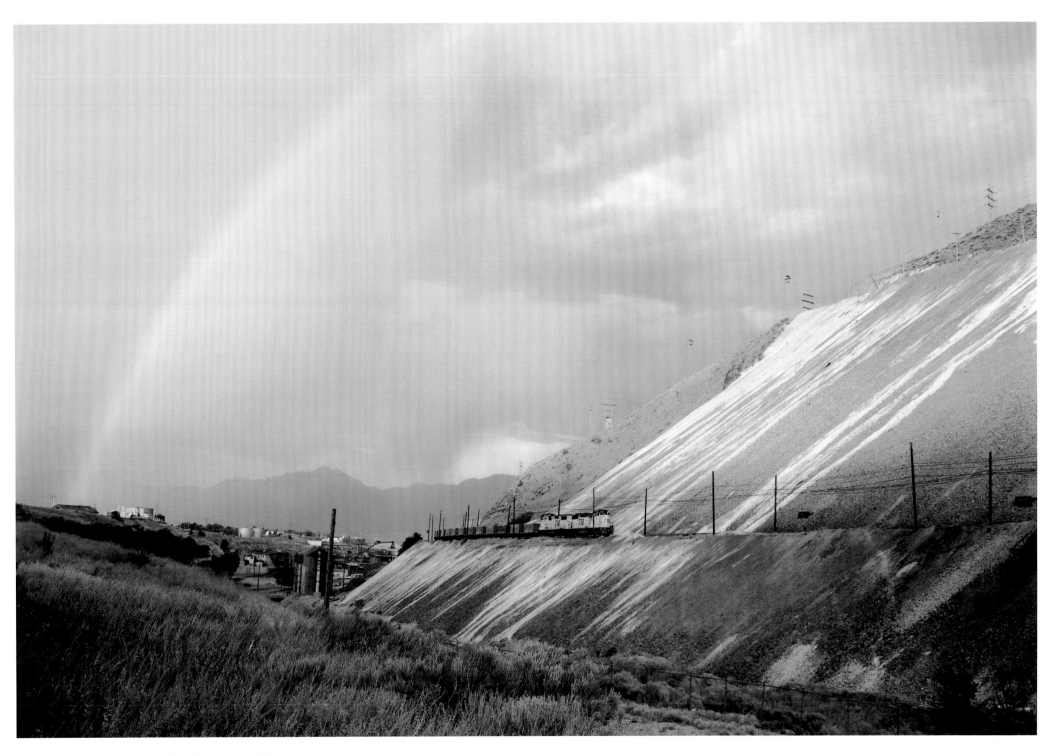

Mine Tailings, Bingham Canyon Mine, Coppertown, Utah

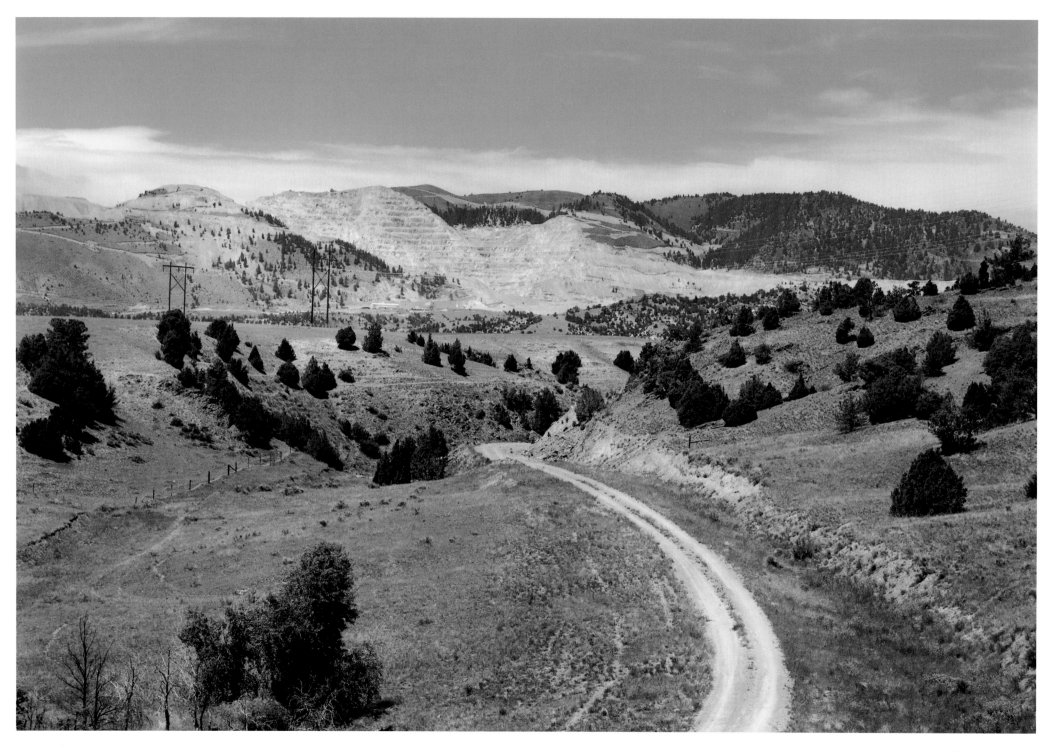

Sunlight Gold Mine, Montana

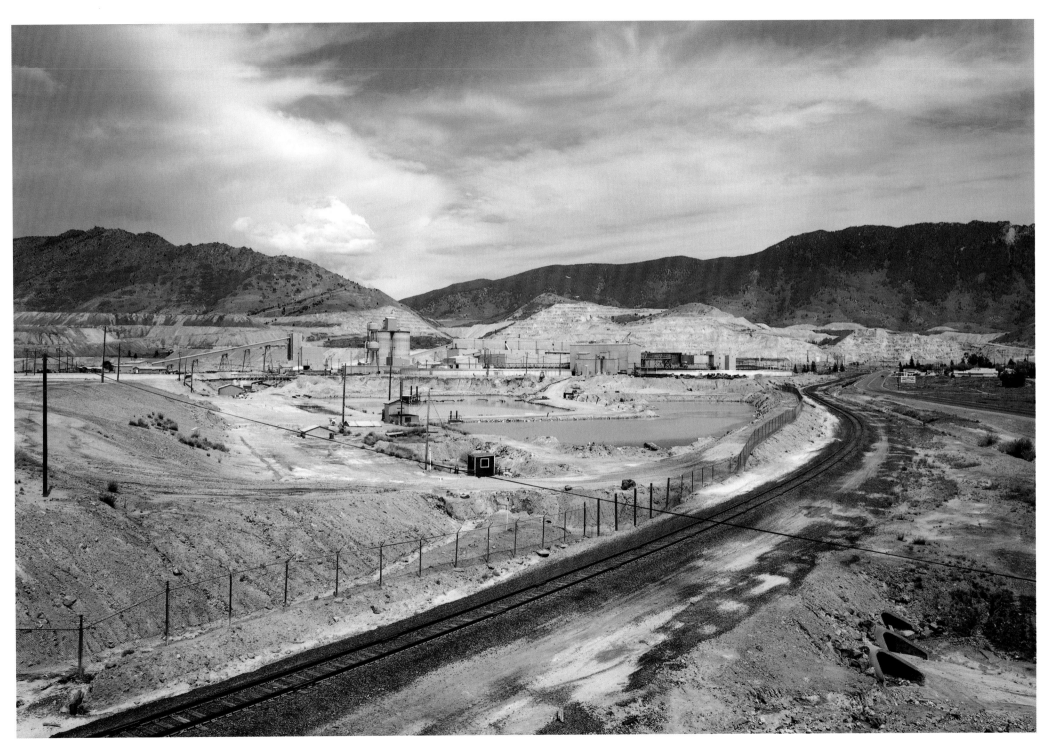

Copper Mine, Butte, Montana

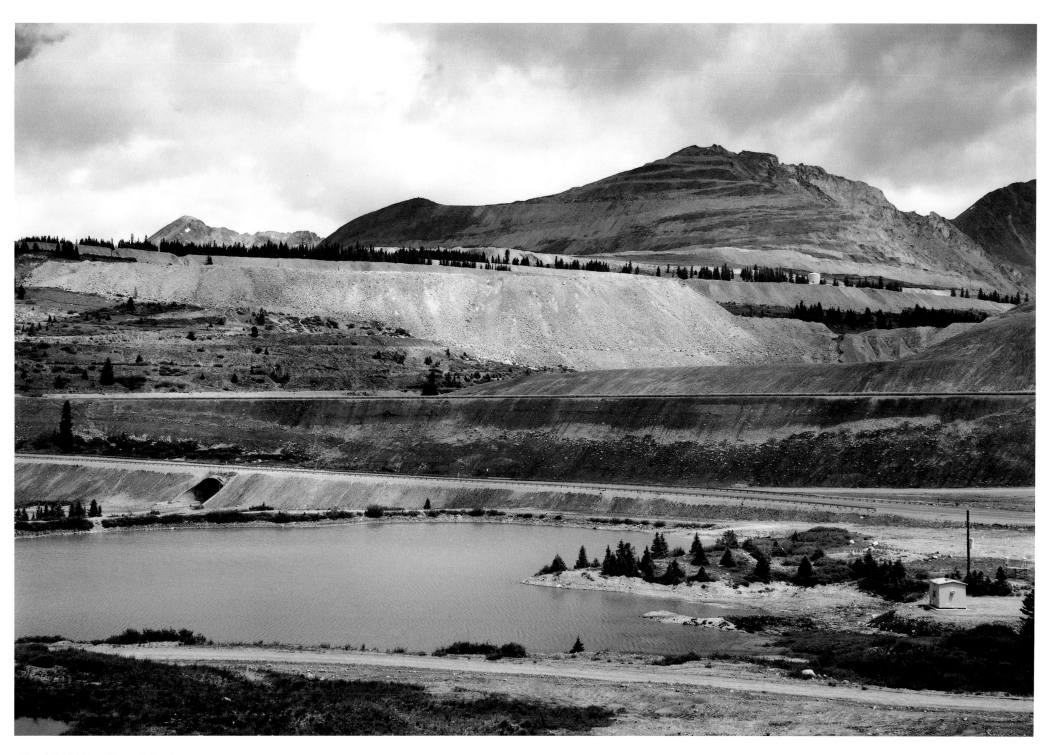

Closed Gold Mine, Climax, Colorado

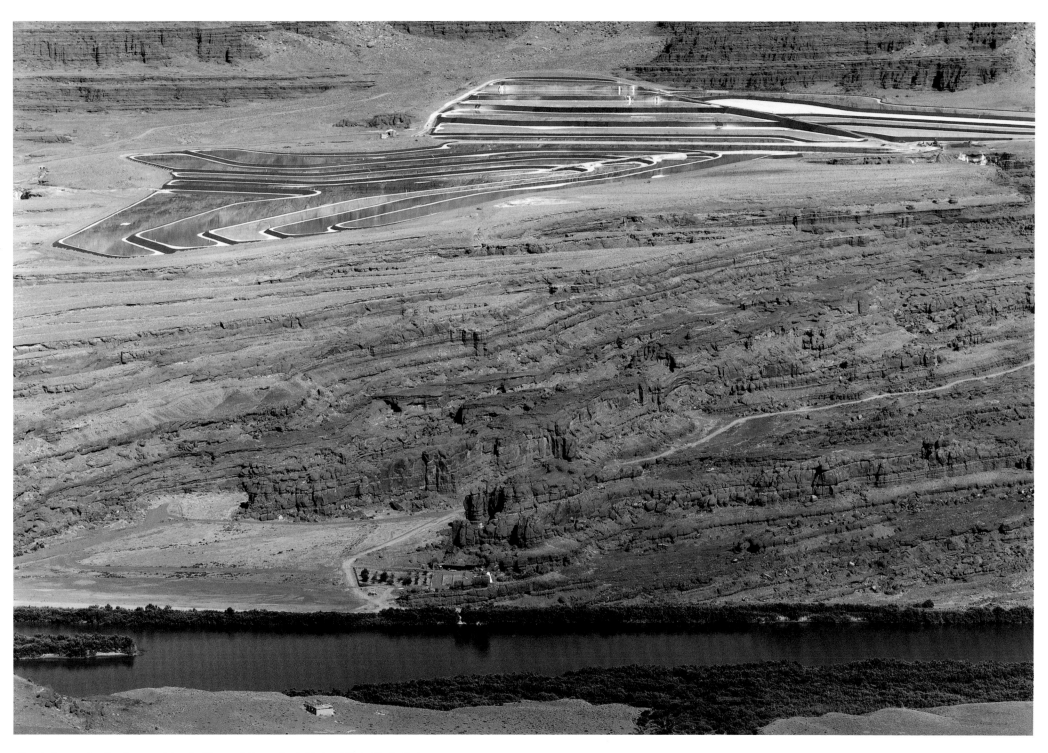

Potash Evaporation Ponds, near Colorado River and Canyonlands National Park, Moab, Utah

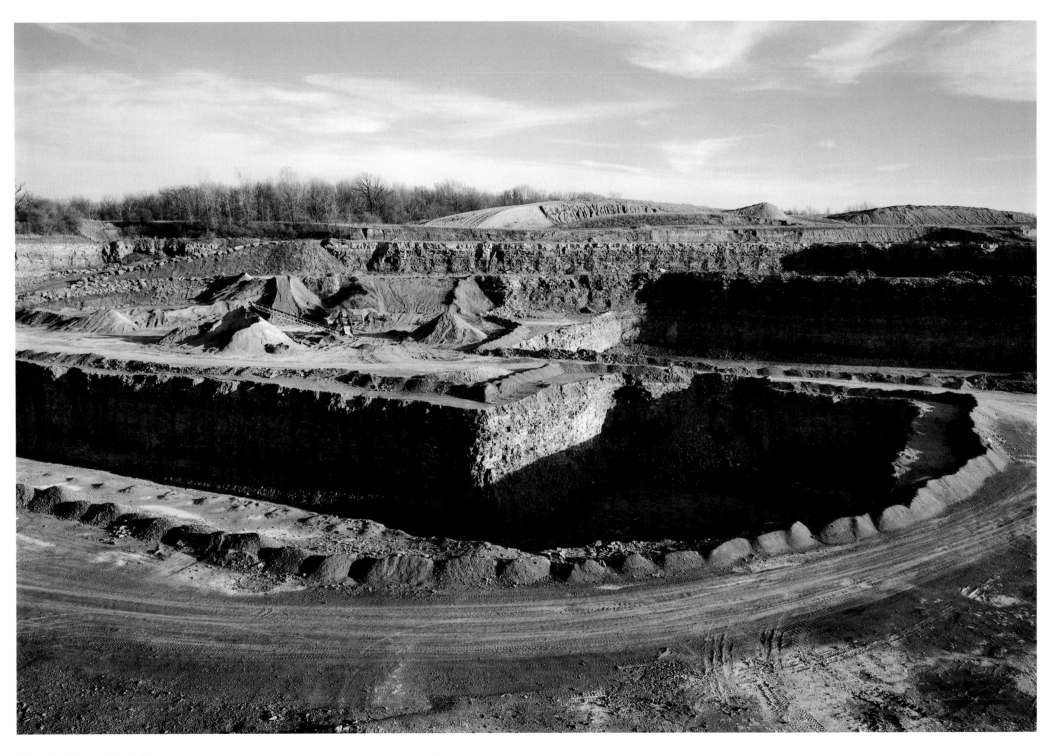

Limestone Quarry, Lima, Ohio

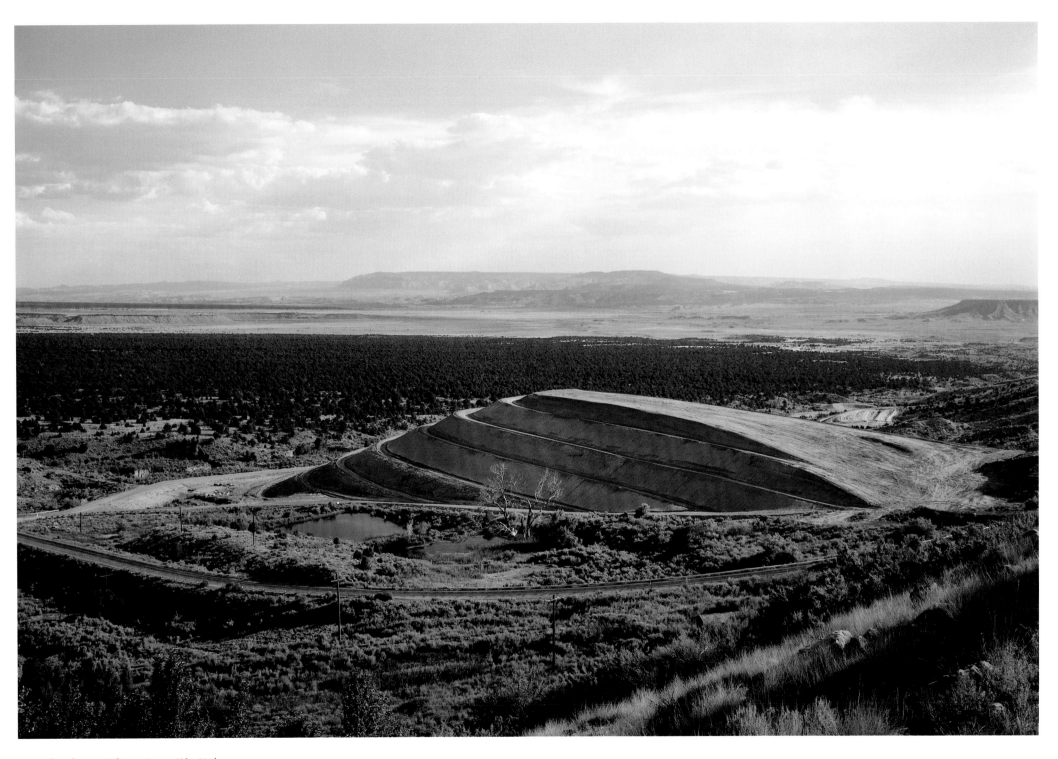

Remediated Mine Tailings, Sunny Side, Utah

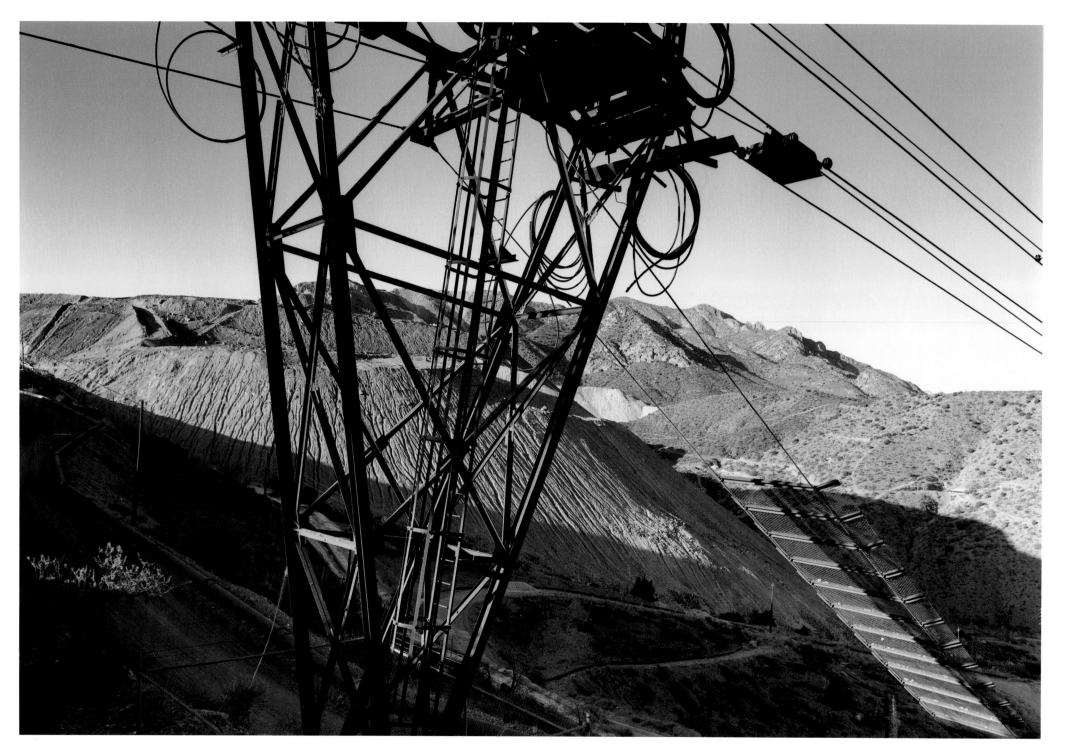

Ore Conveyer Tower, Copper Mine, Morenci, Arizona

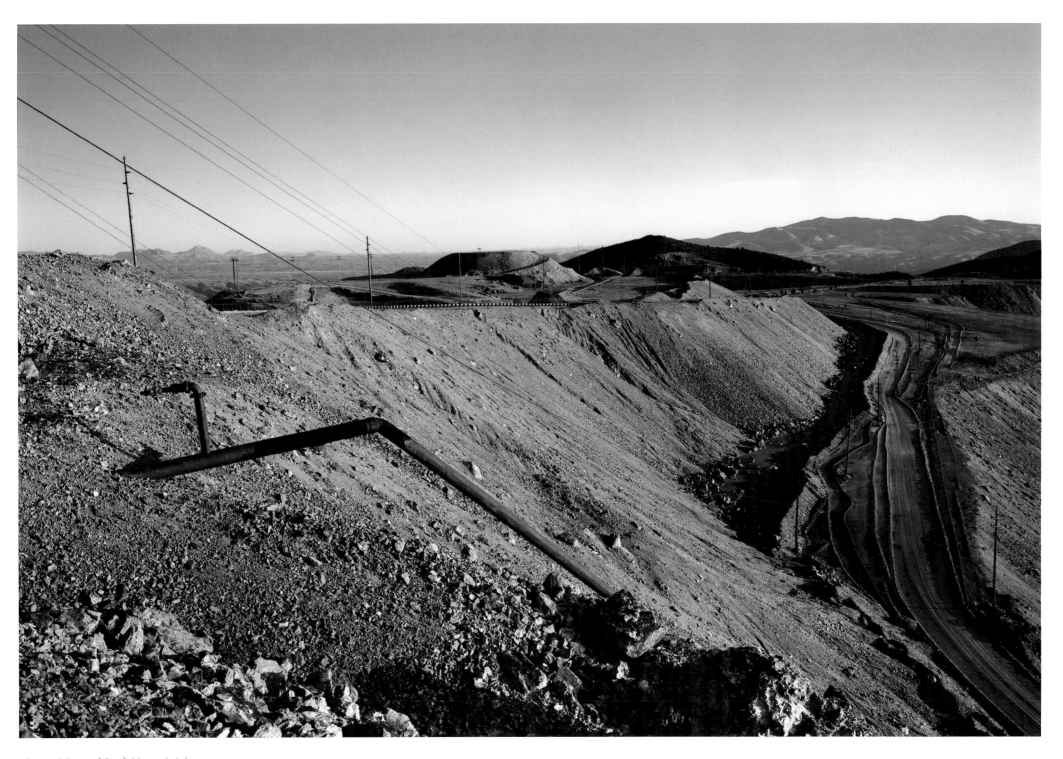

Copper Mine and Road, Morenci, Arizona

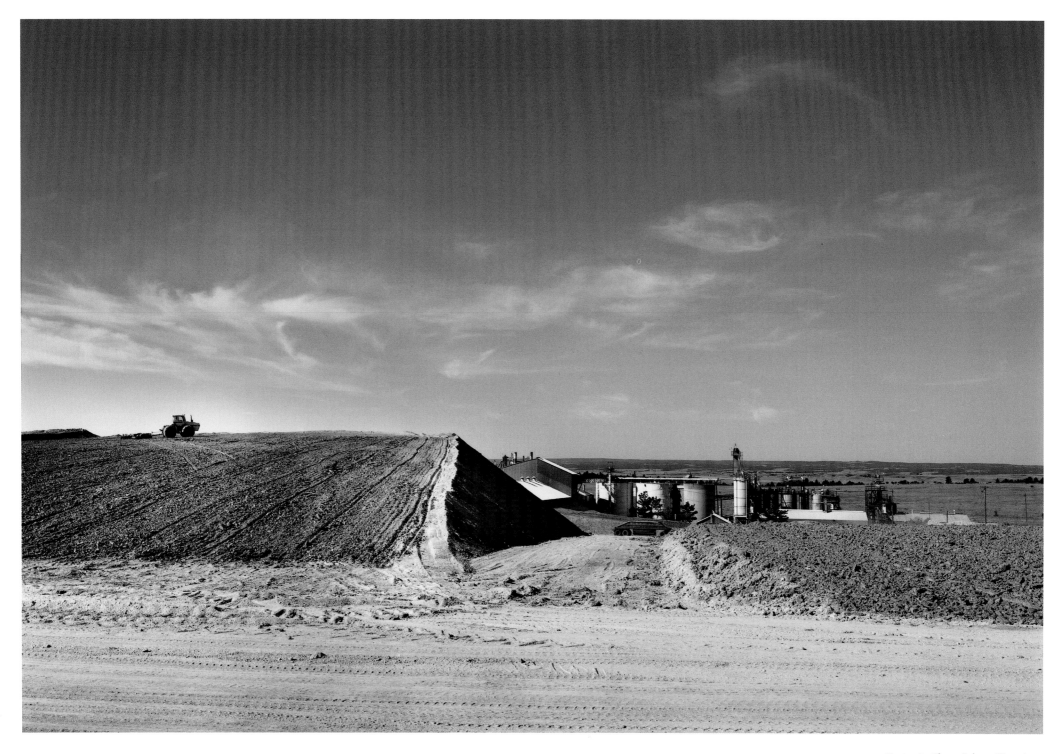

Bentonite Plant, Colony, Wyoming

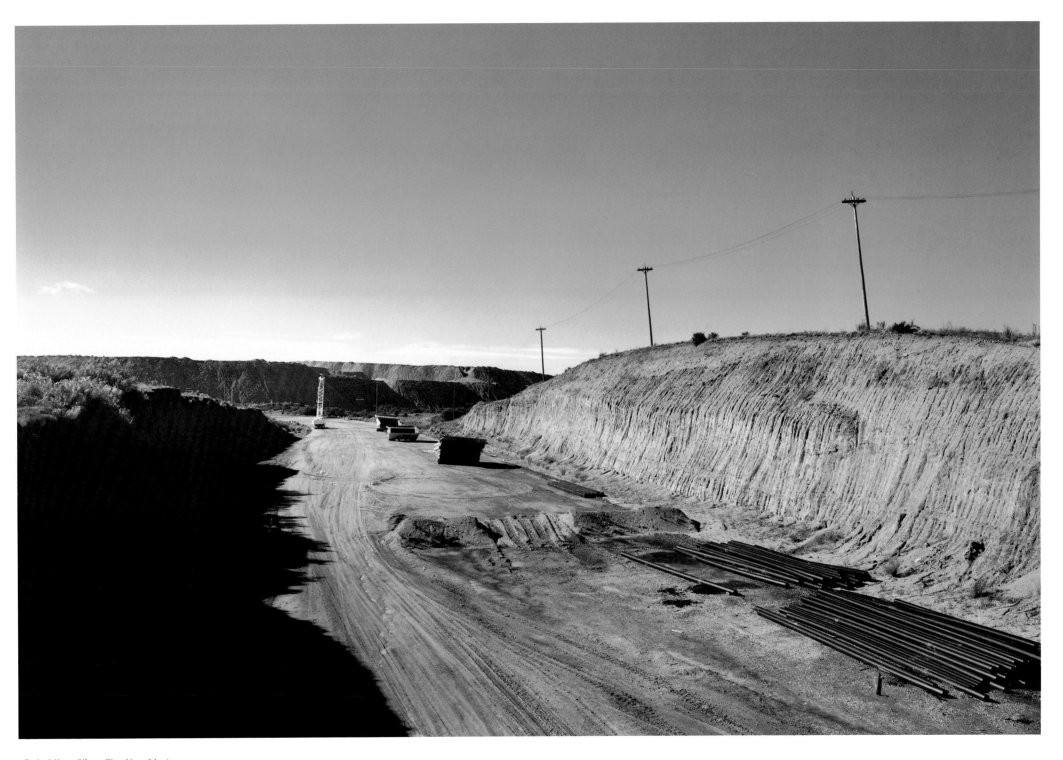

Strip Mine, Silver City, New Mexico

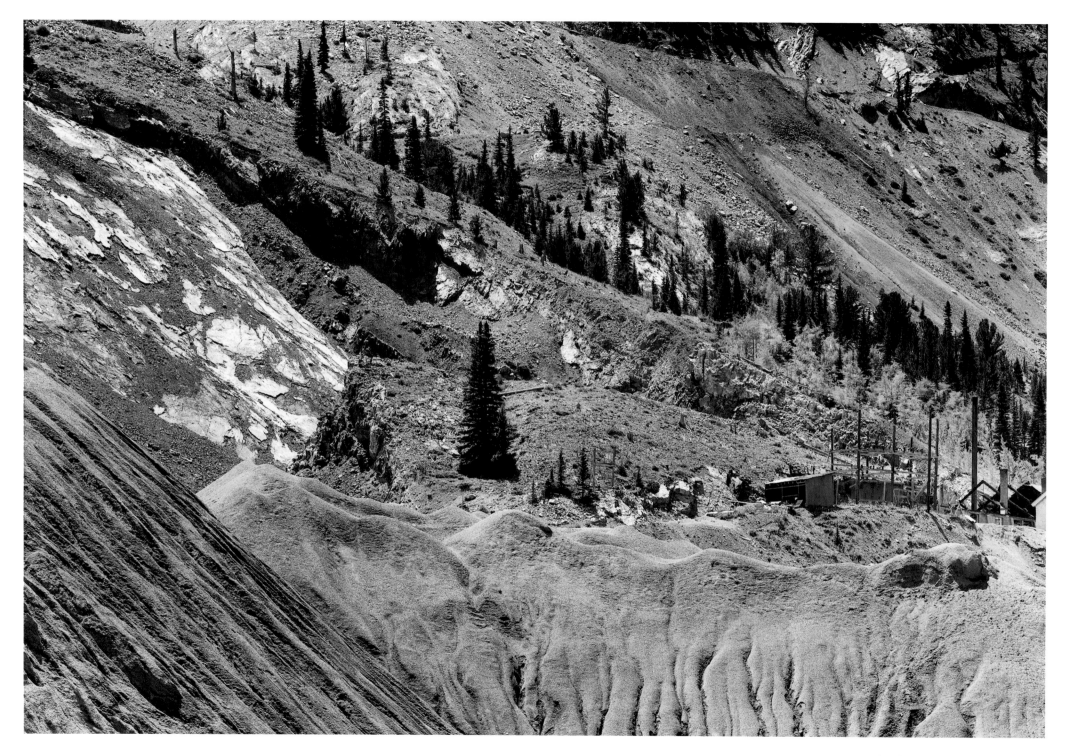

Closed Mine, Monarch Pass, Colorado

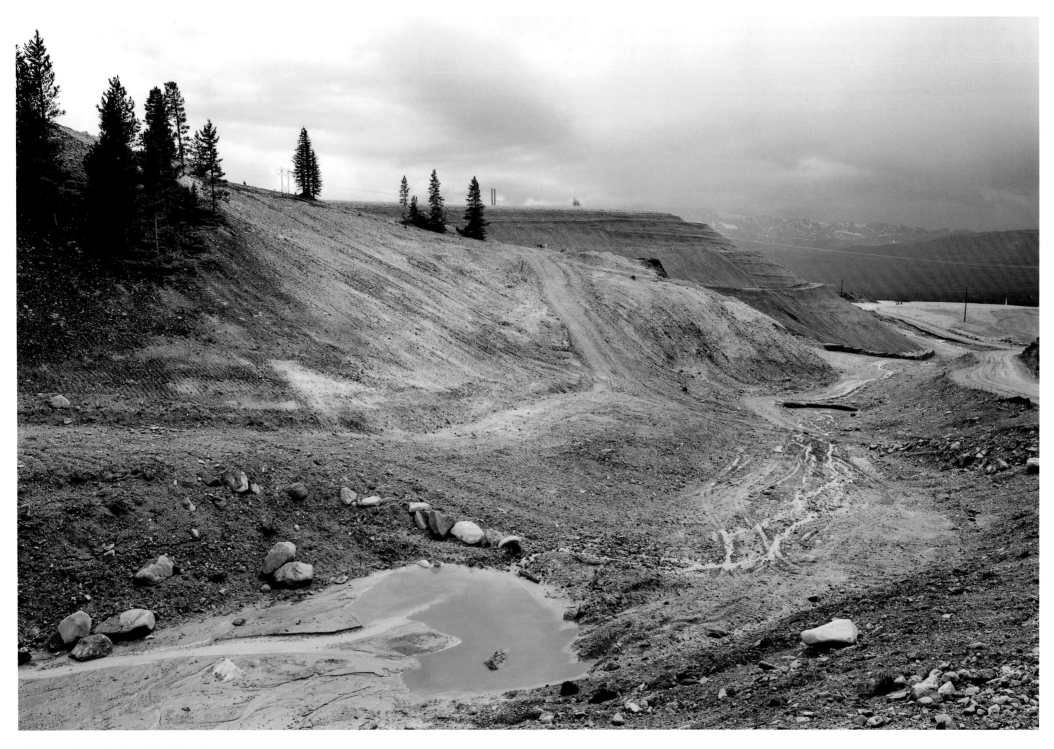

EPA Remediation Site, Leadville, Colorado

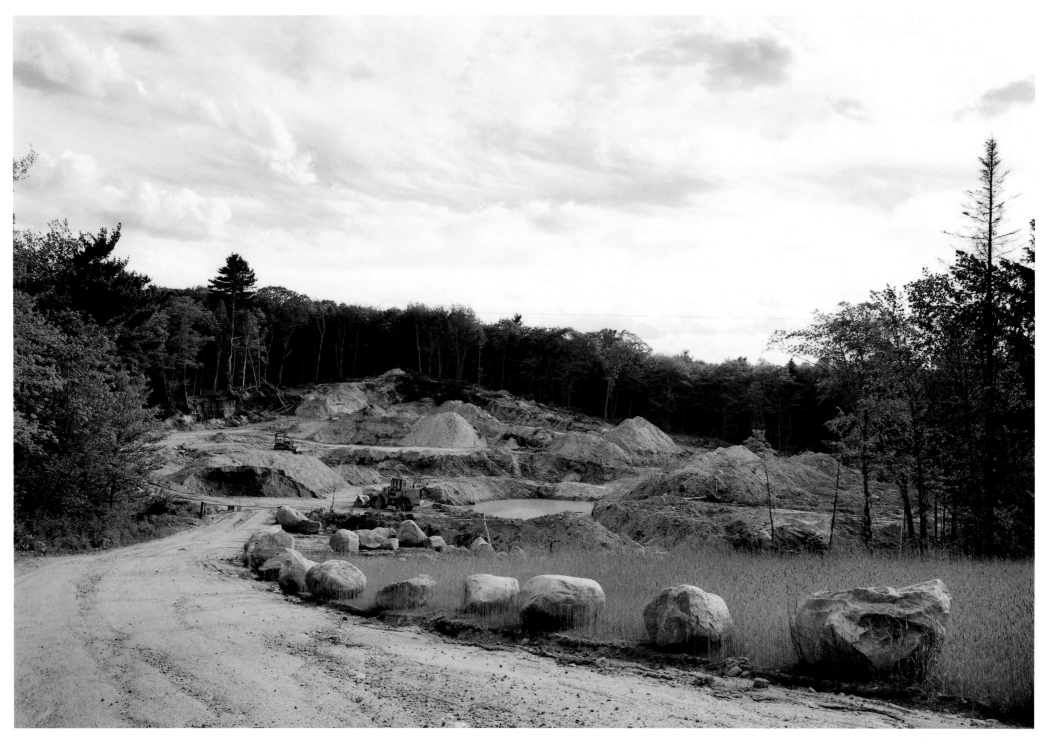

Gravel Pit, Maine

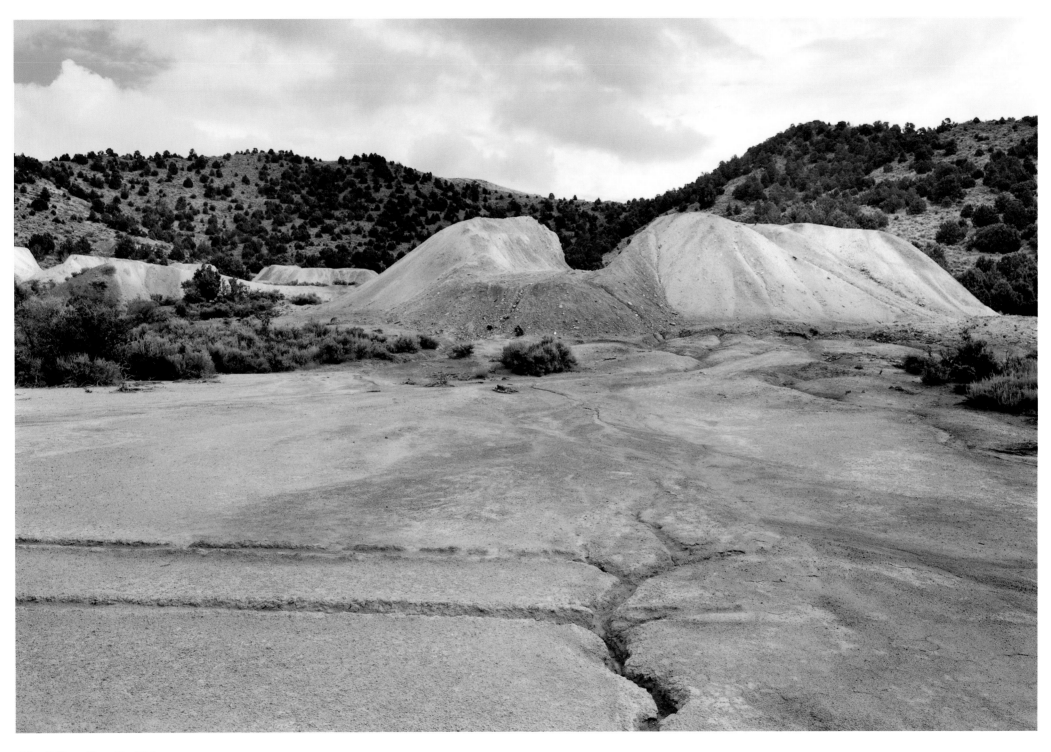

Mine Tailings, Silver City, Utah

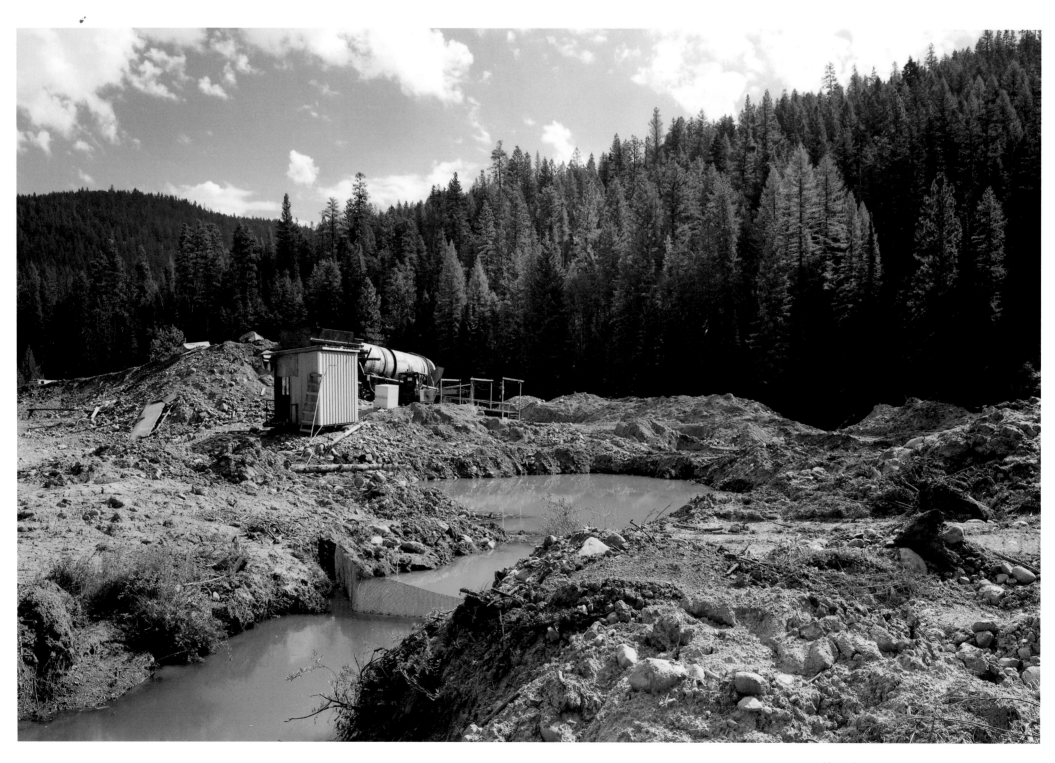

Active Gold Dredging on Cracker Creek, Sumpter, Oregon

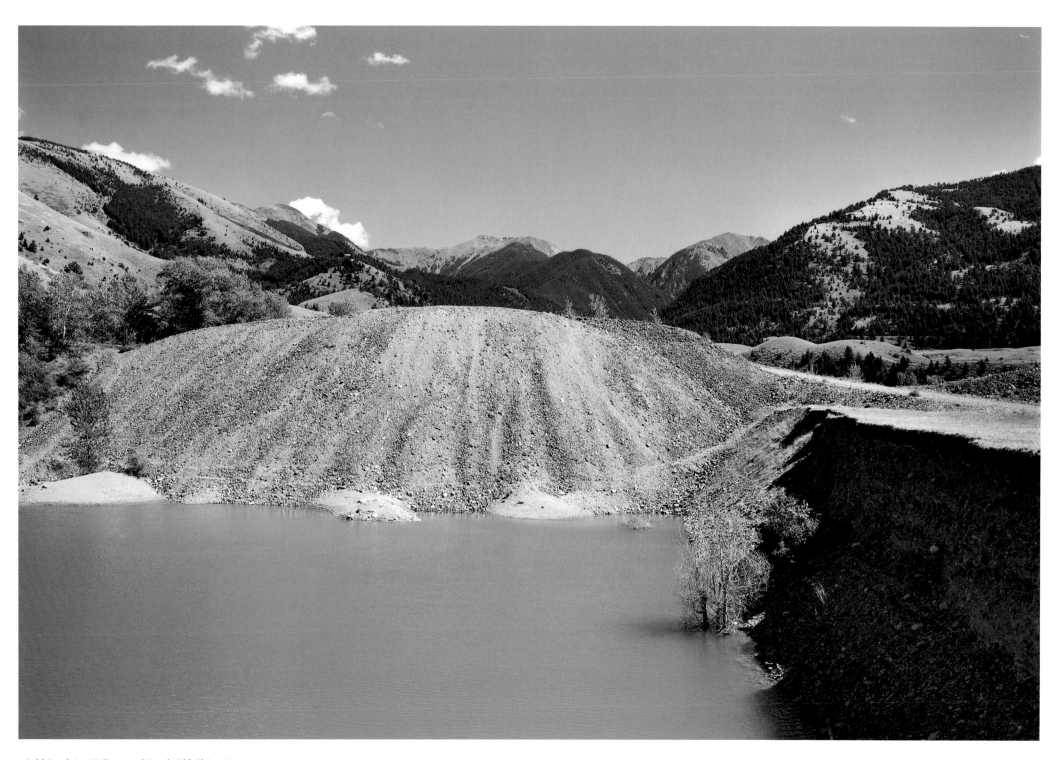

Gold Dredging Tailings and Pond, Old Chico, Montana

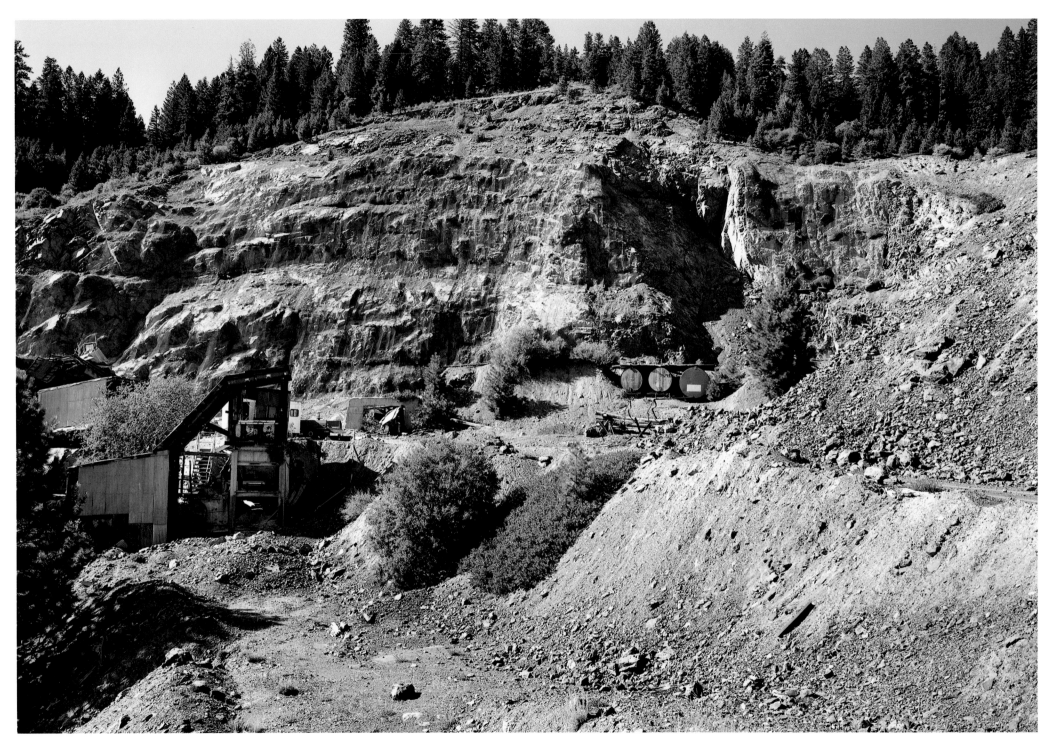

Abandoned Gold Mine, Cupram, Idaho

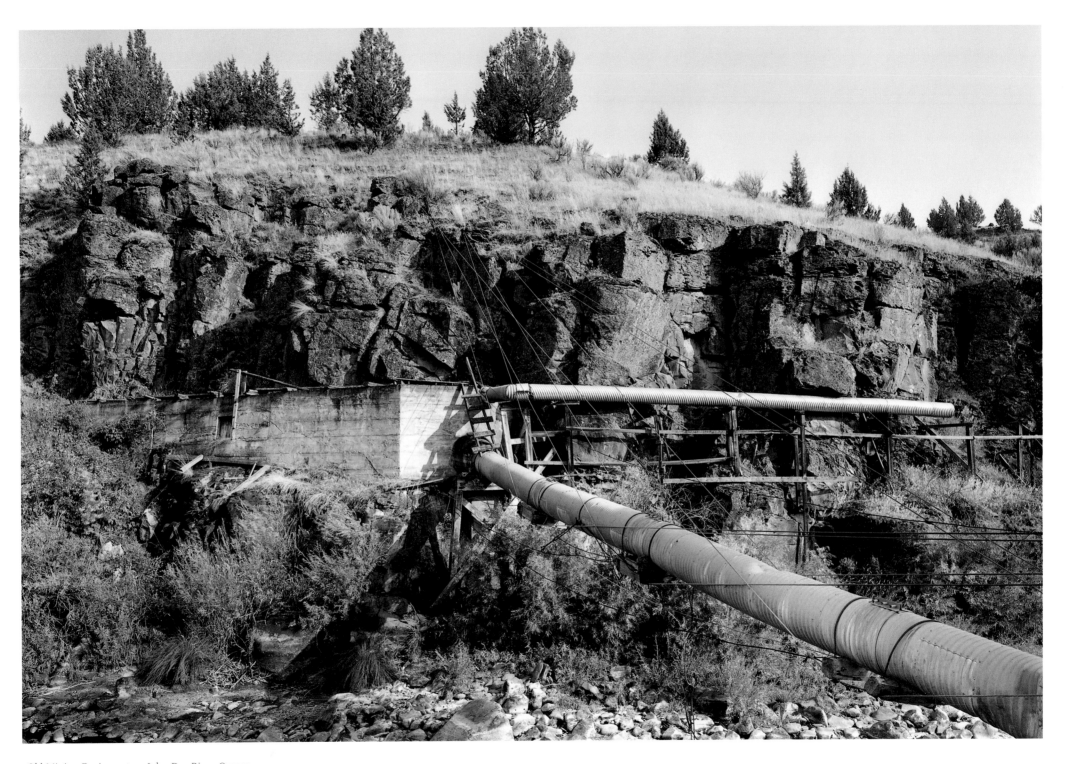

Old Mining Equipment on John Day River, Oregon

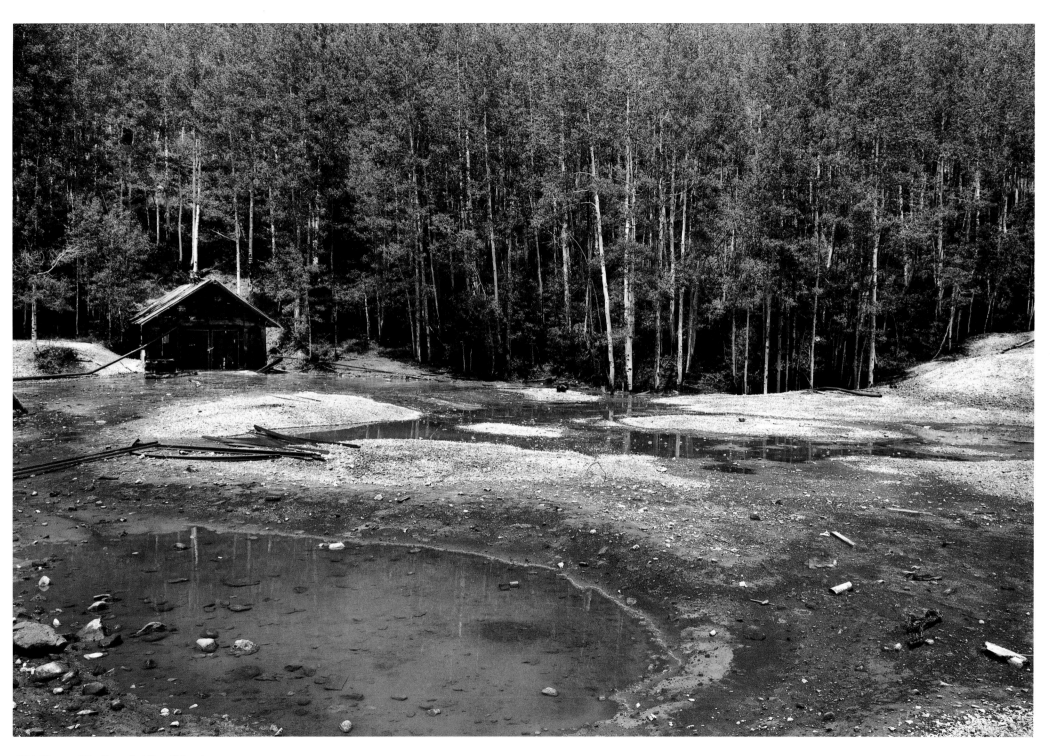

EPA Cleanup Site, Noranda Mine, Colorado

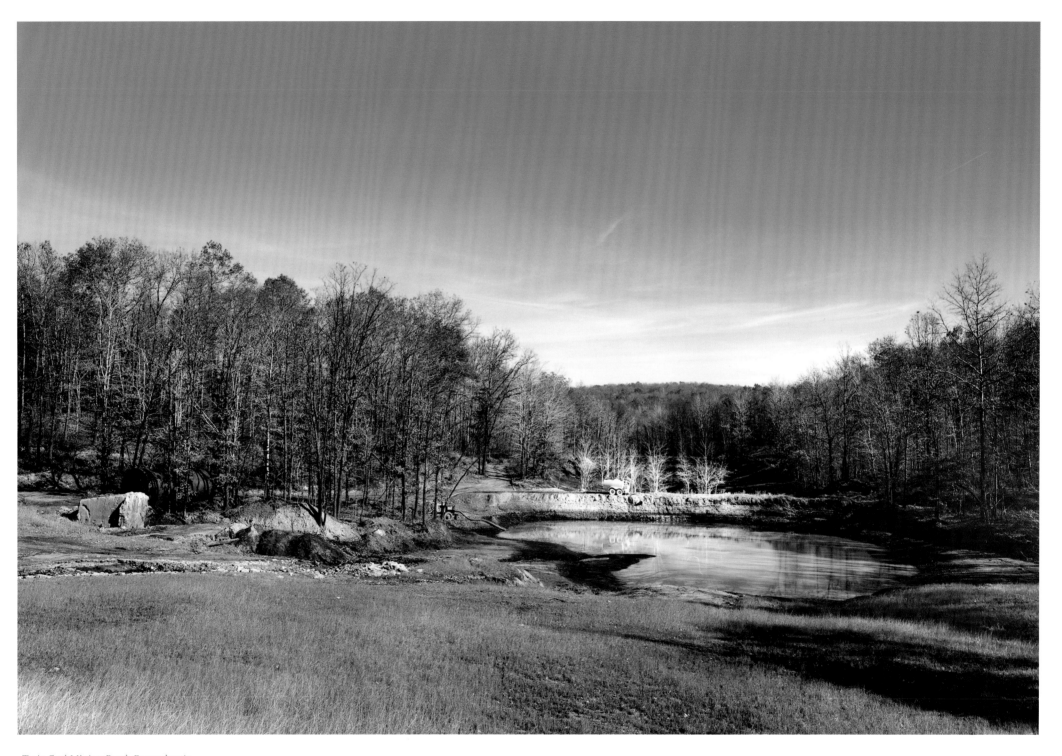

Toxic Coal Mining Pond, Pennsylvania

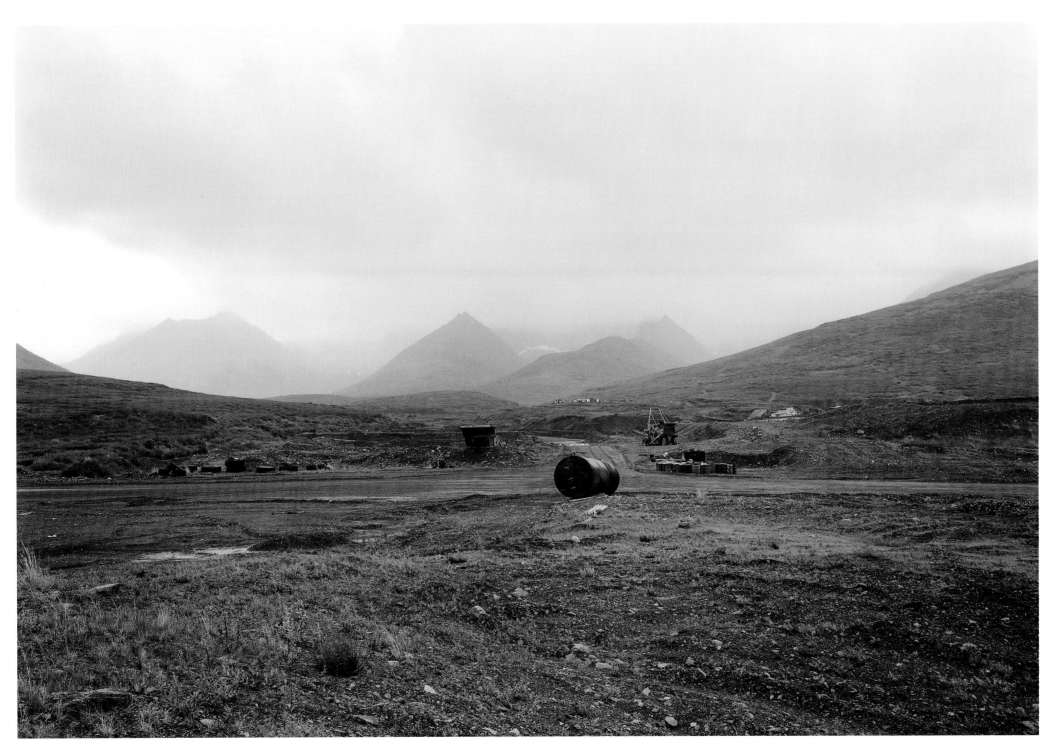

Gold Mine, Valdez Creek, Alaska

The small farms are gone
And with them
The last tie to the land
Who will care for the land
Now that the small farms are gone
Who will understand the land
Or think themselves part of the land
Who will measure their lives
Against the rhythms of the seasons
Who will know
The workings of the sun
And the shifting winds
The meanings of soil
And the culture of Corn
The integrity of seeds
Now that the small farms are gone
And who will sense
The bond between sowing and reaping
Or hear the night
Sweeping the eaves
Of staunch simple houses

And where have the small farmers gone
To the factories in the cities, of course
And now there are factories in the fields
Where the small farms used to be
The land is a tundra
Of forced crops
And frozen animals
A vast poisonous yield
While farmers die
In factories
In the city
Or in the field

Who will remember the small farms
And their farmers

Who will mate with this land

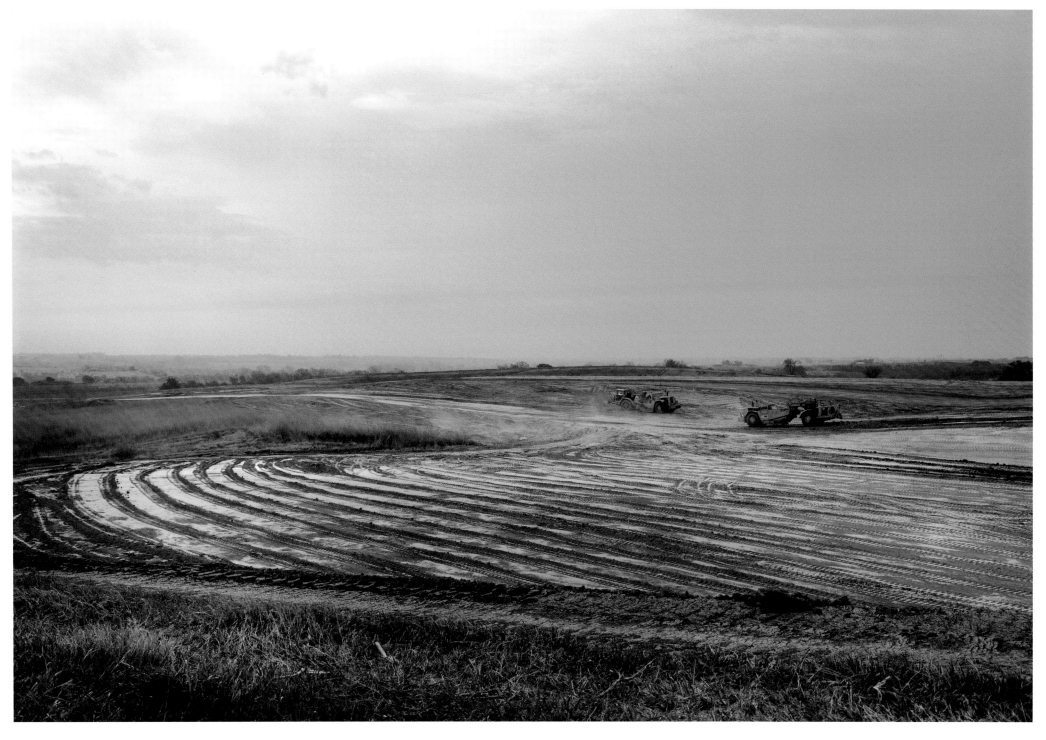

Development of Farm Land, Iowa

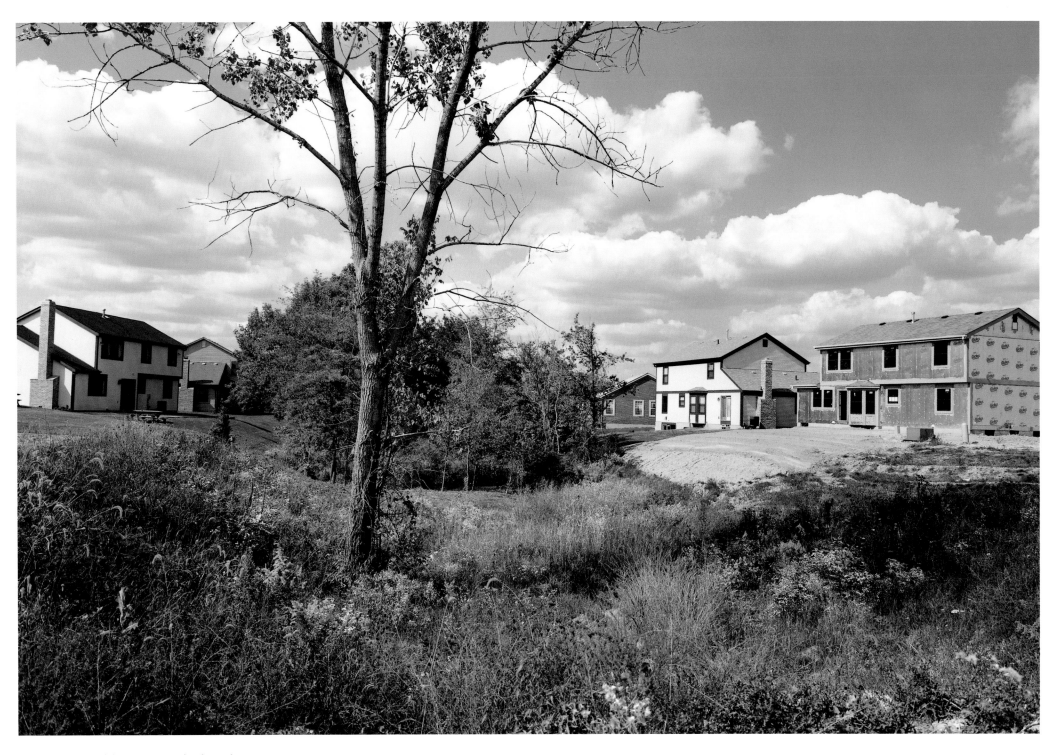

High Meadows Subdivision, near Columbus, Ohio

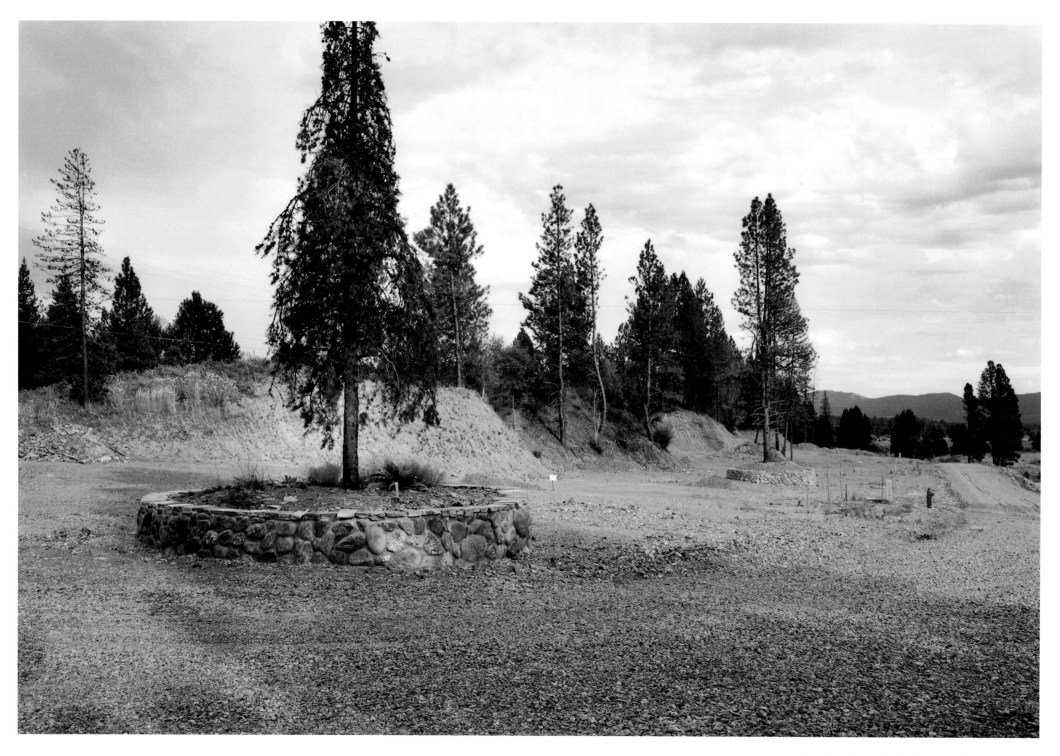

Iron Horse Housing Development, Sumpter, Oregon

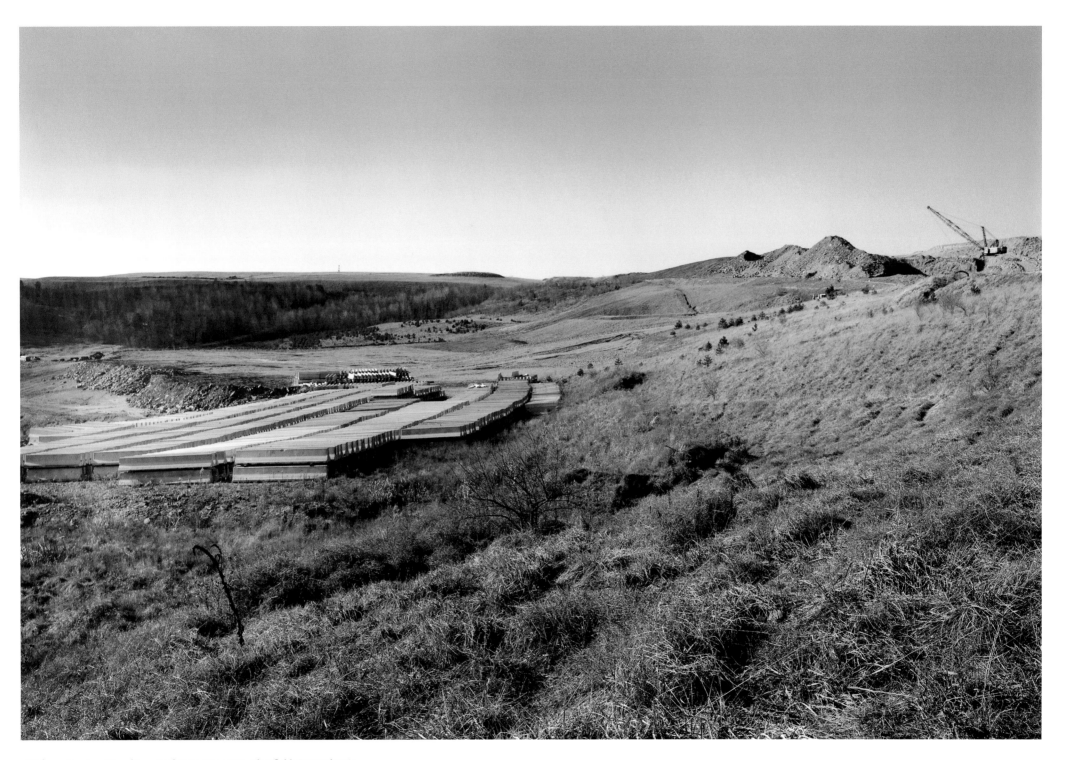

Highway Barriers Stored in a Coal Strip Mine Site, Clearfield, Pennsylvania

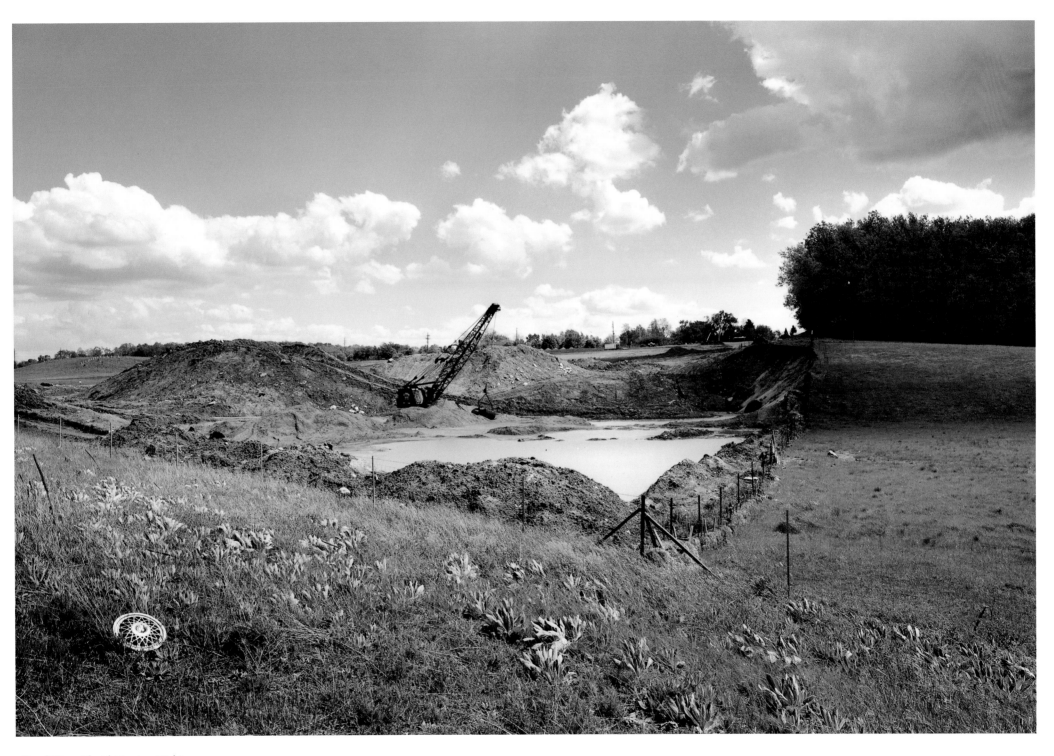

Gravel Pit on Glacial Moraine, Michigan

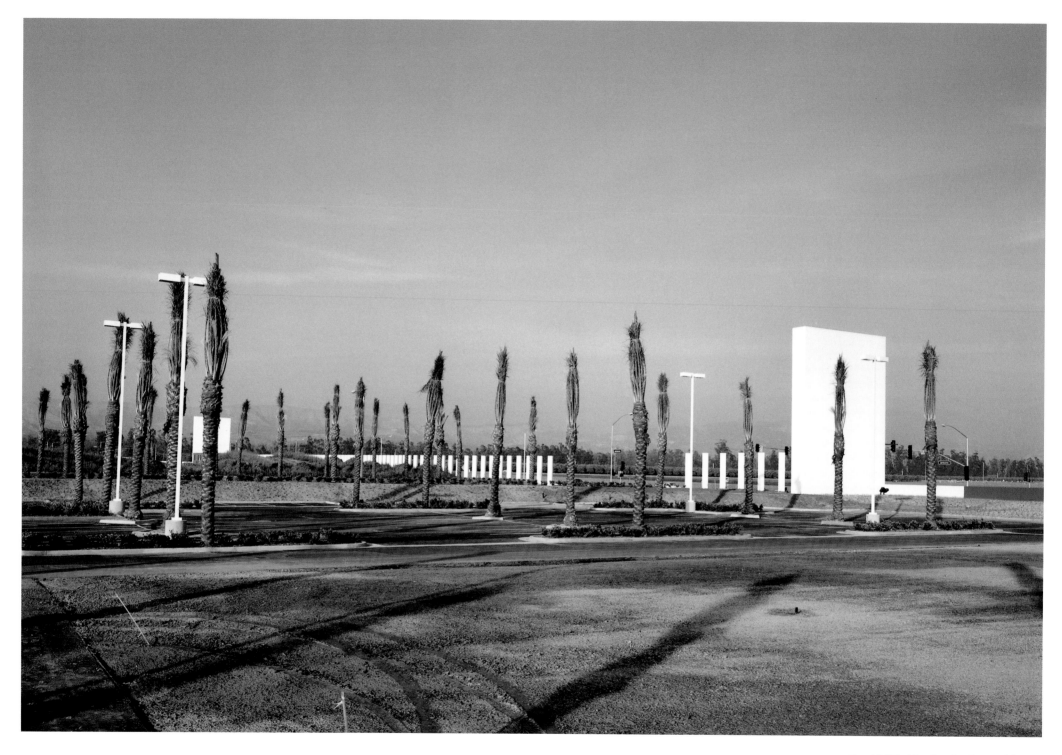

New Mall Parking Lot, Southern California

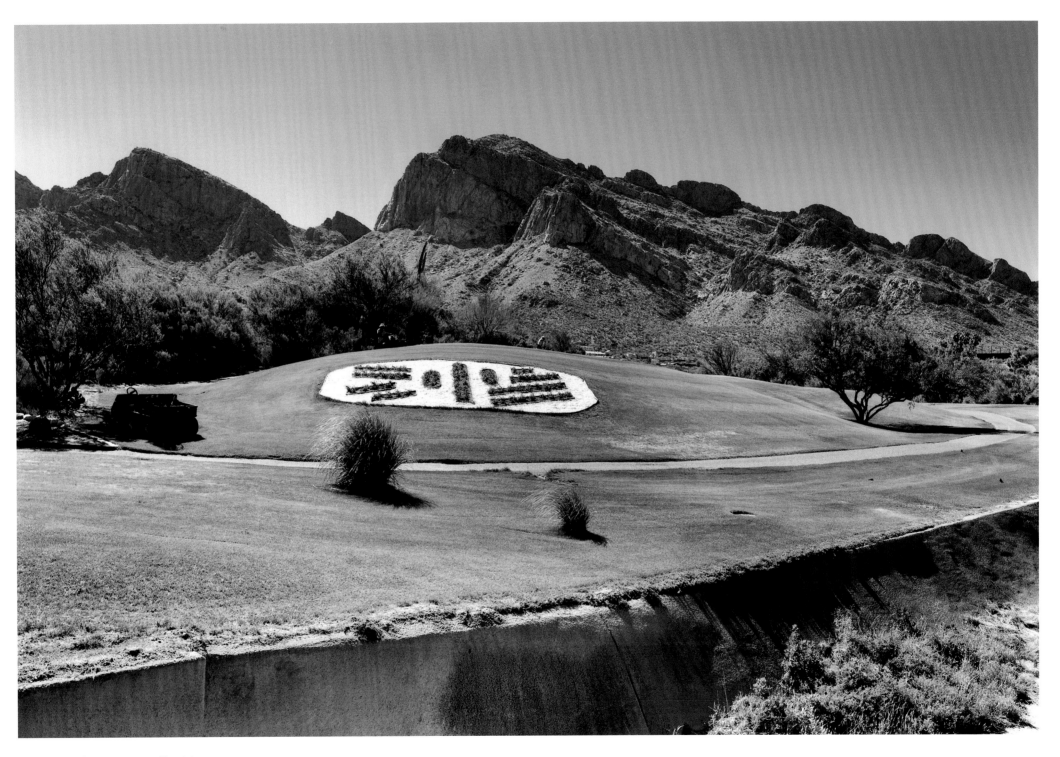

El Conquistador Resort, Oro Valley, Arizona

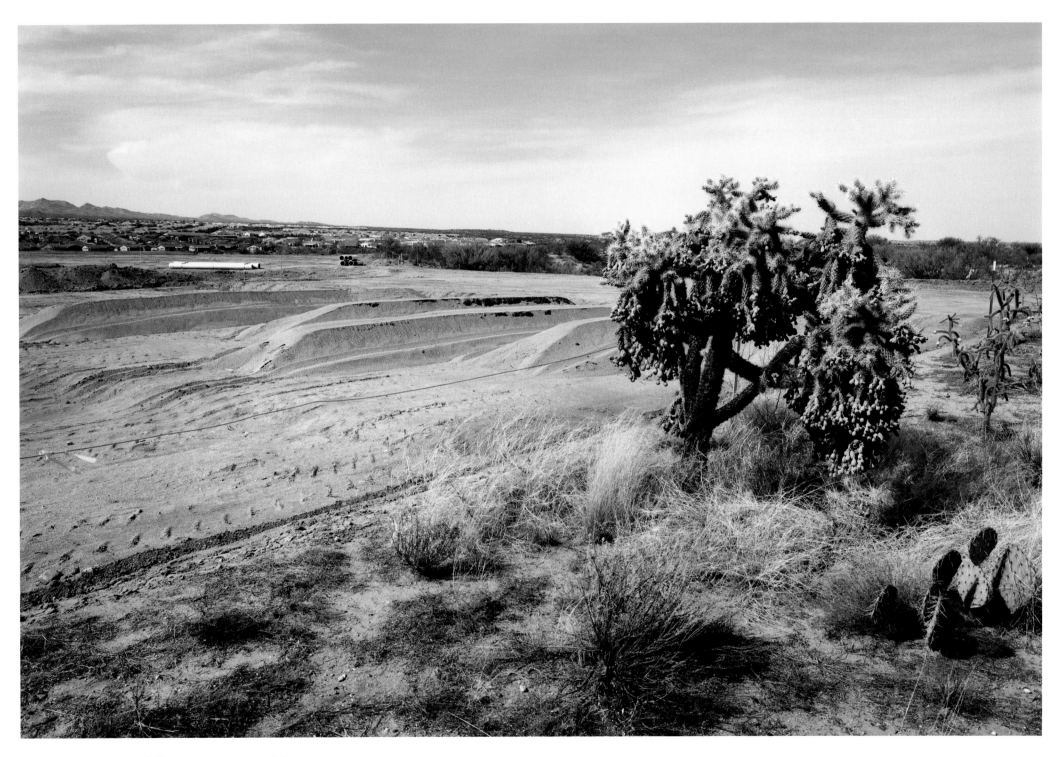

Housing Development in Cholla Forest, Sonora Desert, Arizona

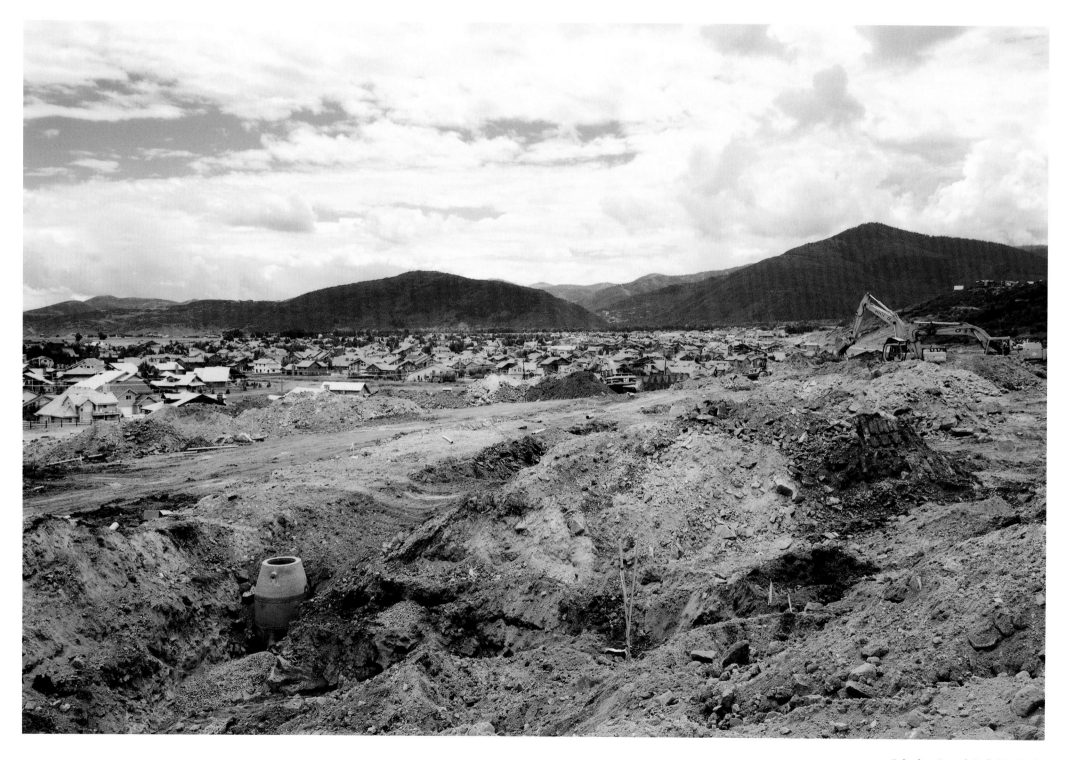

Suburban Sprawl, Park City, Utah

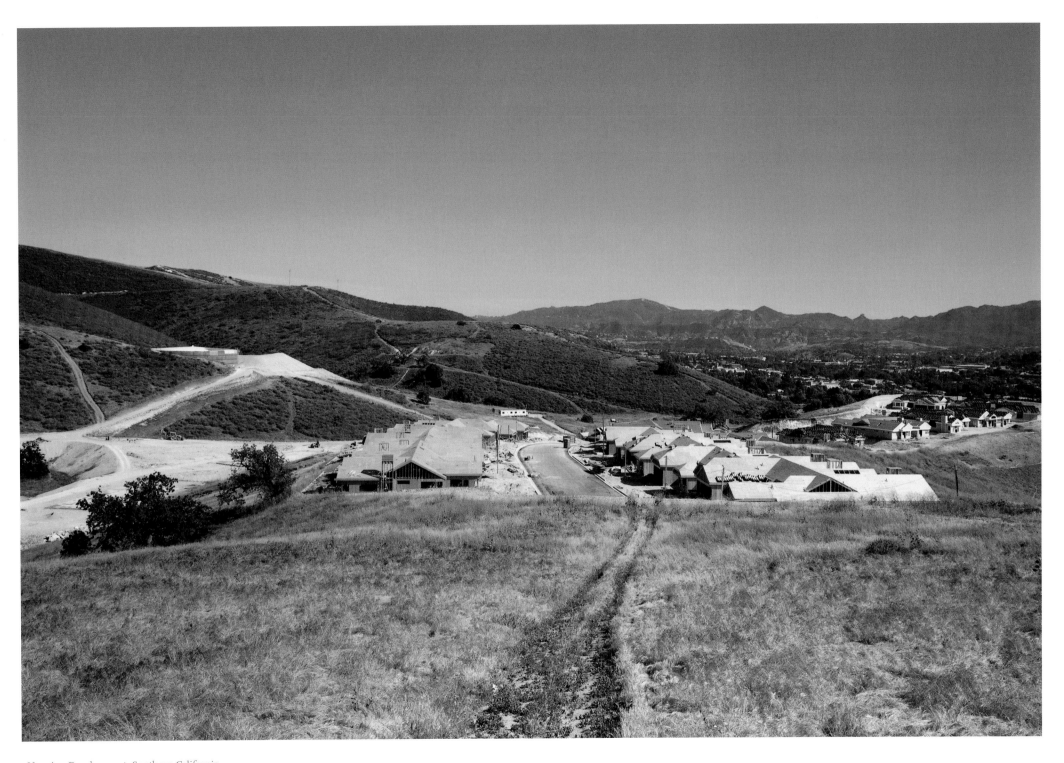

Housing Development, Southern California

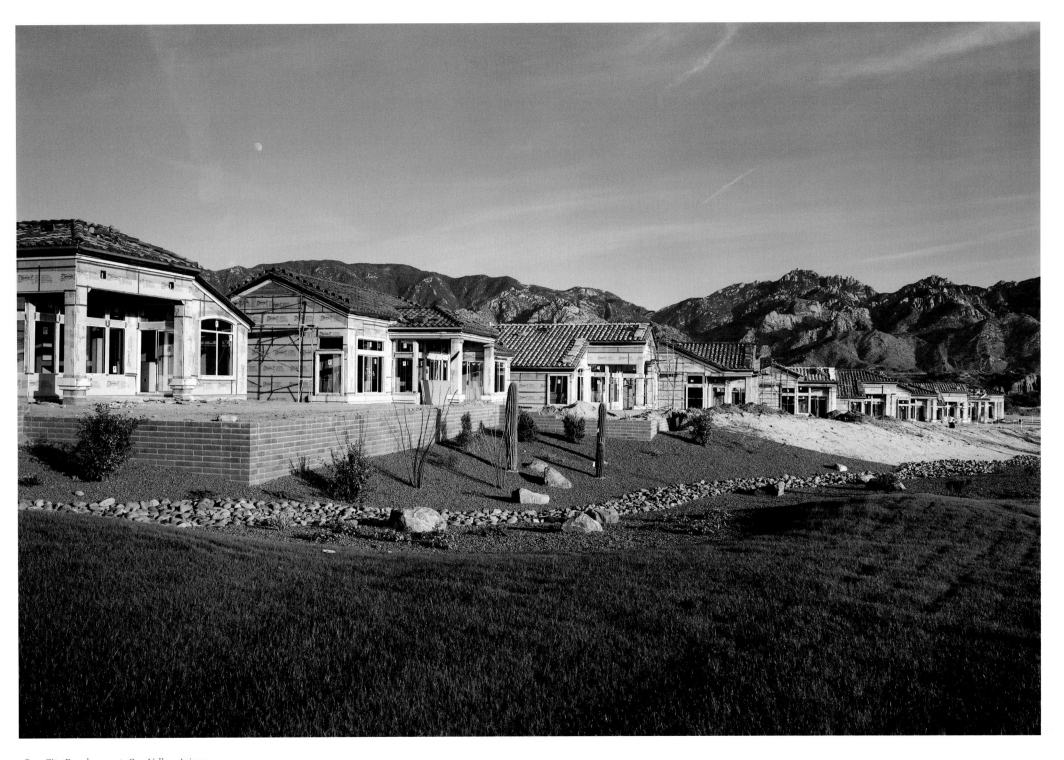

Sun City Development, Oro Valley, Arizona

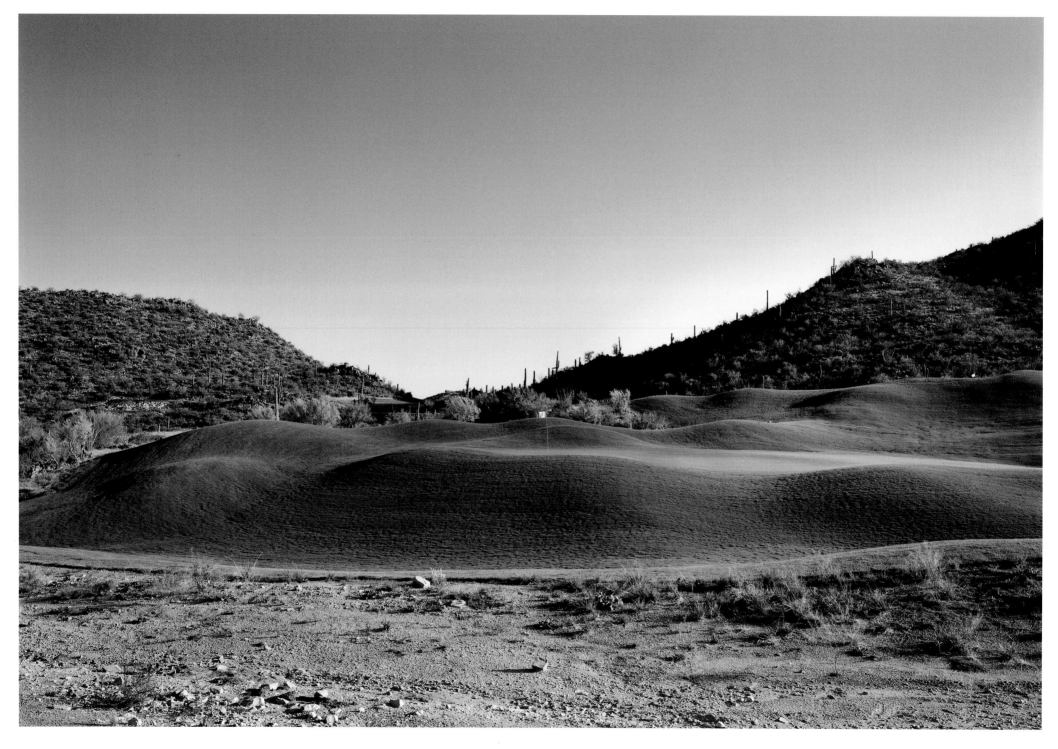

Golf Course, Sonora Desert, Arizona

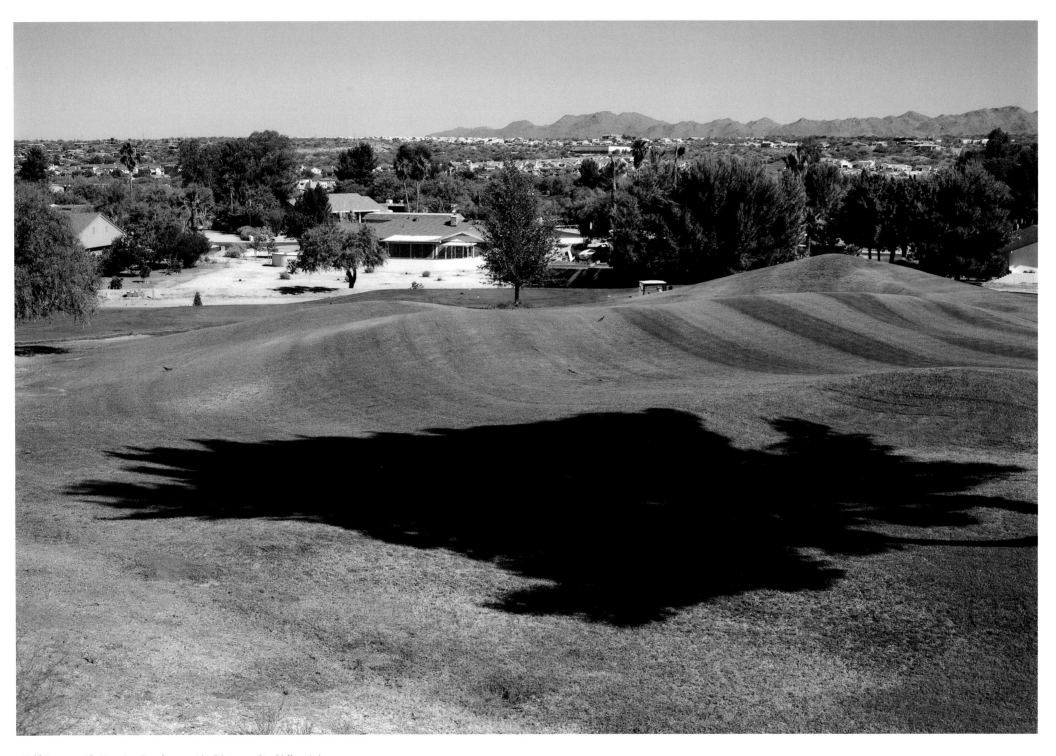

Golf Course with Housing Development in Distance, Oro Valley, Arizona

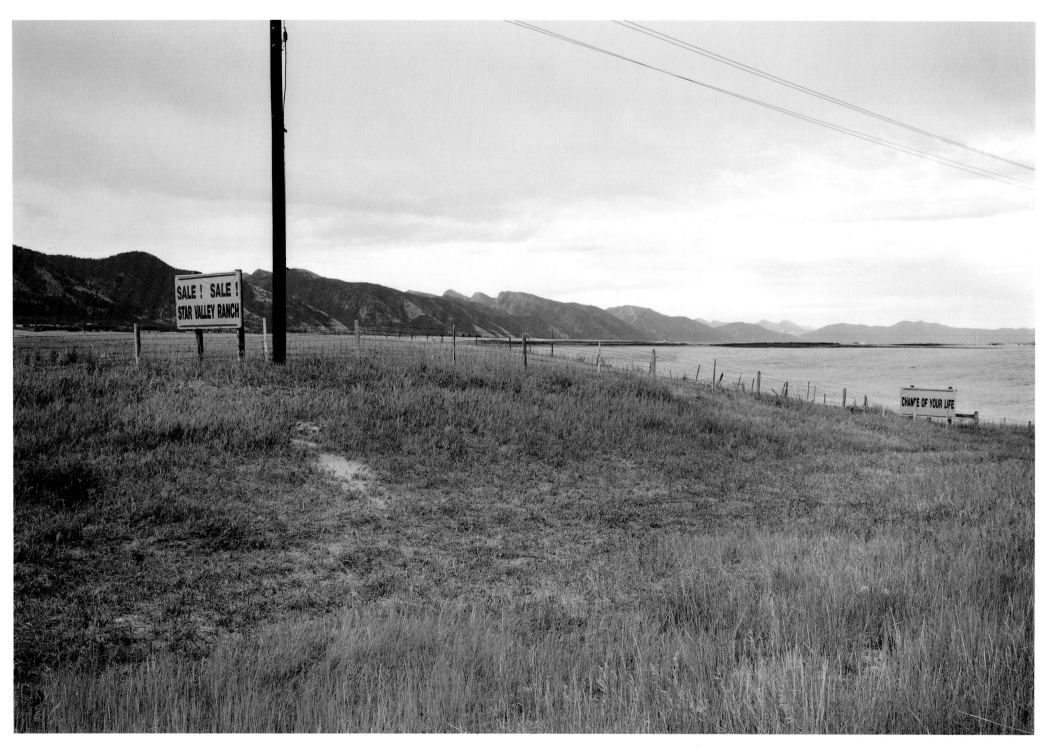

Developer's Sale, Star Valley, near Freedom, Wyoming

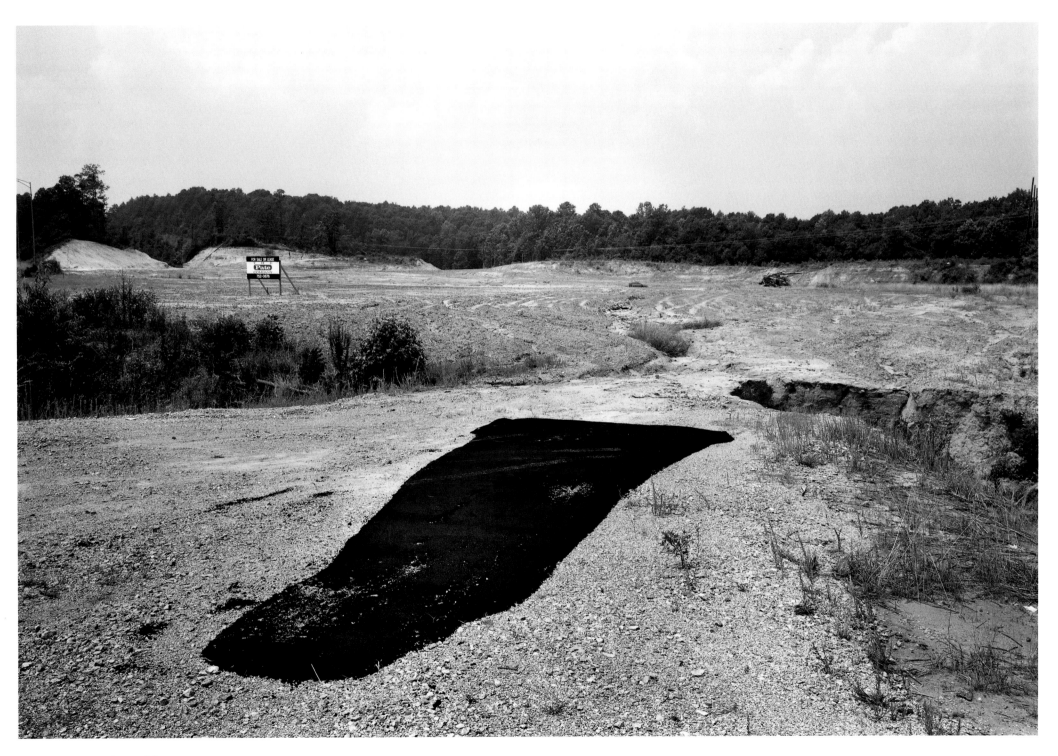

Land for Sale, Tuscaloosa, Alabama

The dream of profit
is a bad dream

Of flat horizons
and cracked cement

Of vast magnetic malls
capping the wells
of history

In barren halls
reluctant predators
aimless nomads
refugees of grief
track goods
and hunt each other
across a waste
of counters
gathering nothing

Beneath the cracked cement
rotting wire
beneath the wire
a rotting field
beneath the field
a thousand sacred objects
trapped seeds
and the iron stumps
of ruined trees

The dreams of profit
are bad dreams

From such dreams
we will not awake

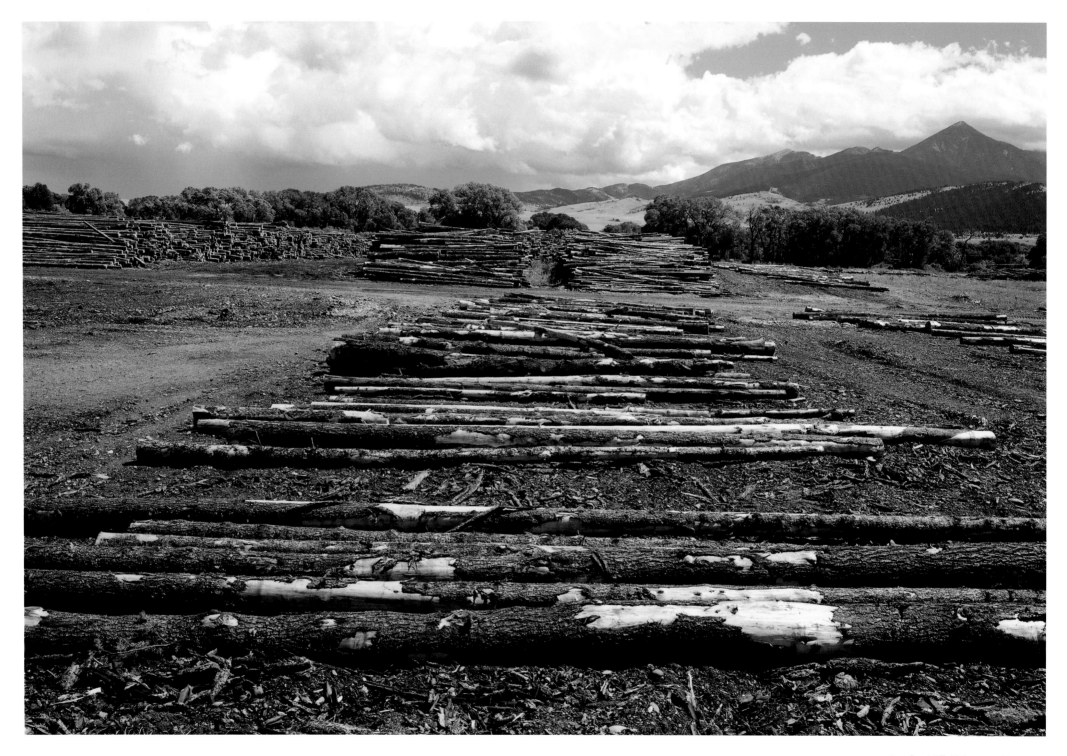

Lumber Mill, Livingston, Montana

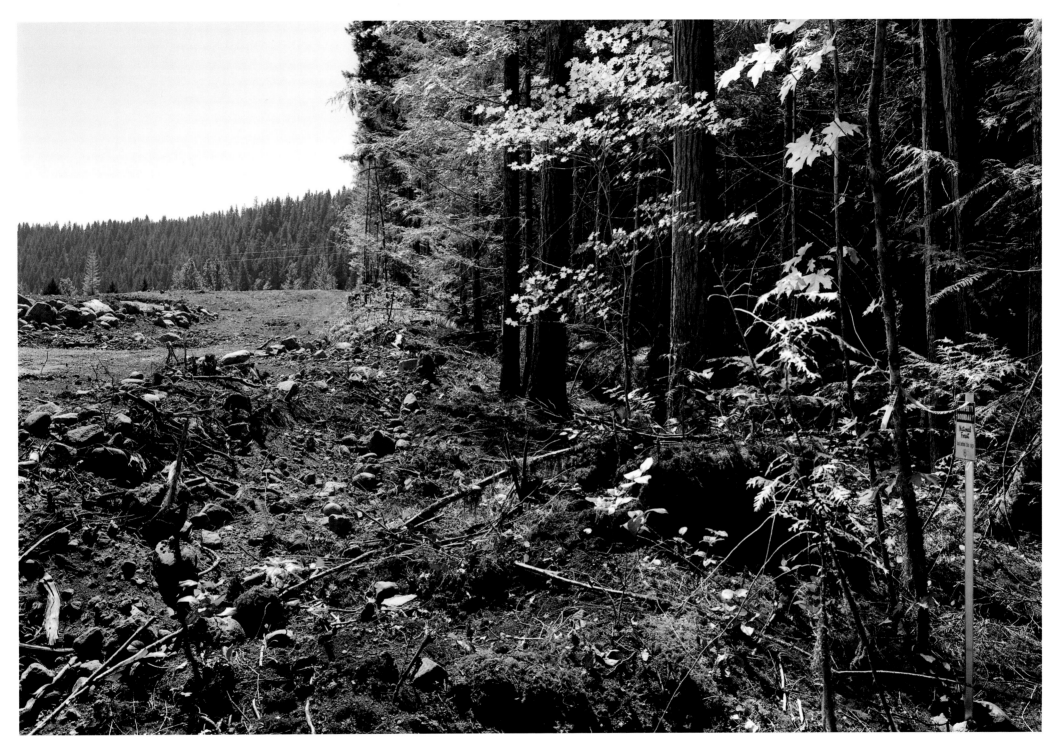

Boundary of the Willamette National Forest, Oregon

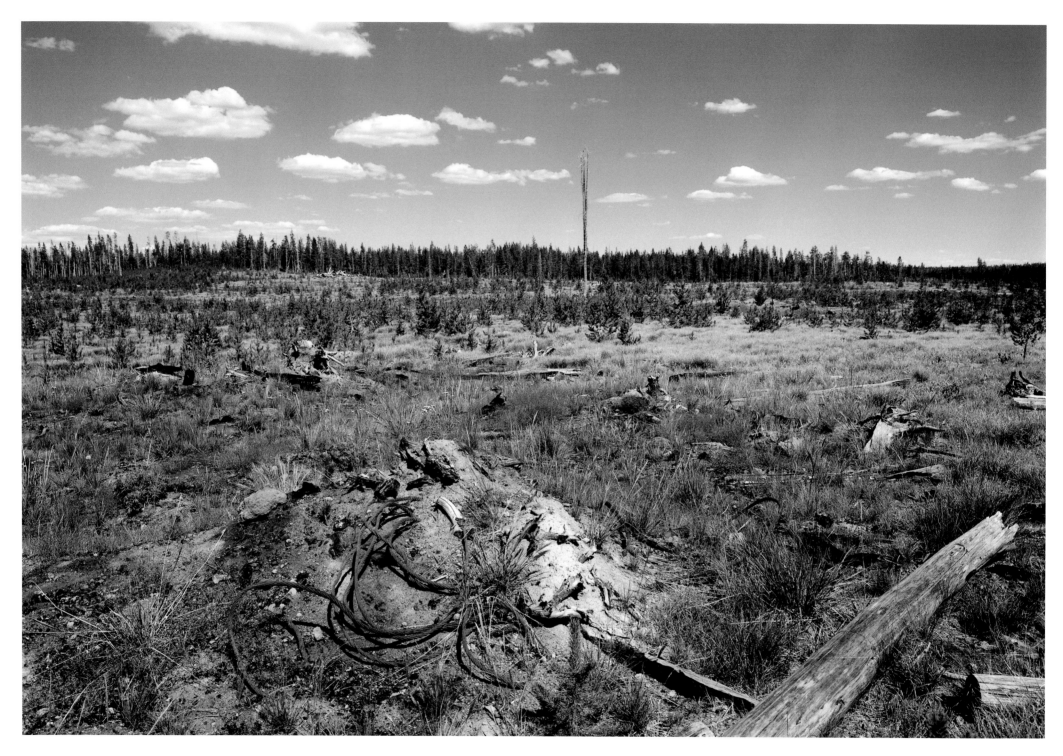

Logging Cables in Clear Cut, Targee National Forest, Idaho

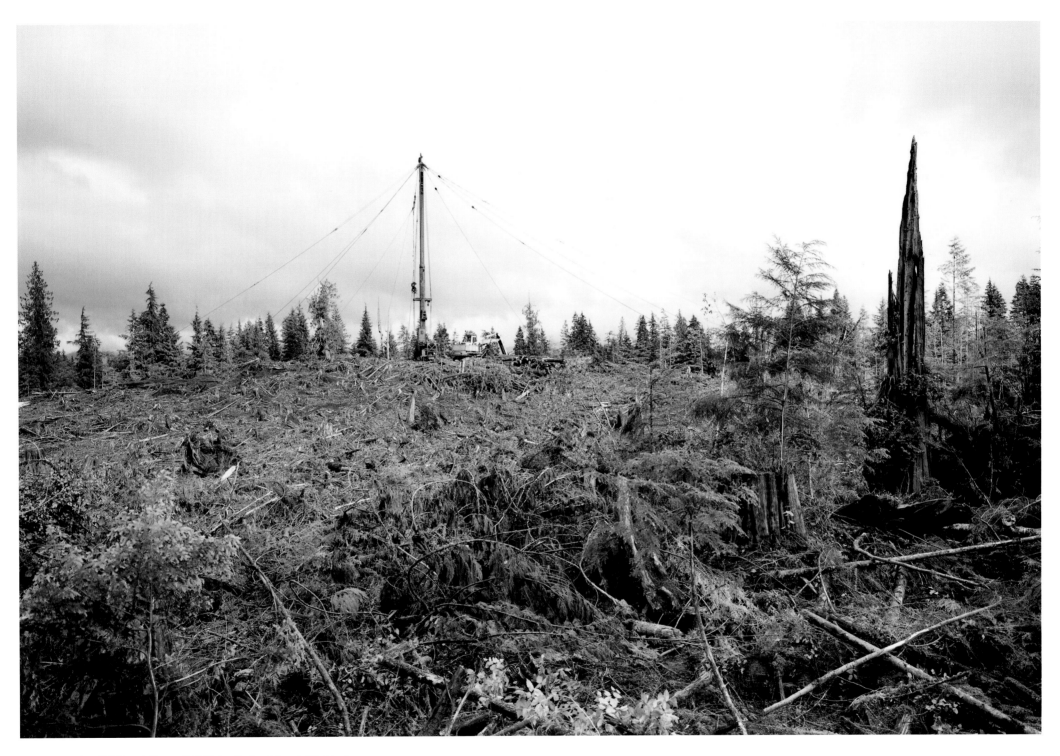

Logging Yarder, Old Growth Forest, Hoh Valley National Forest, Washington

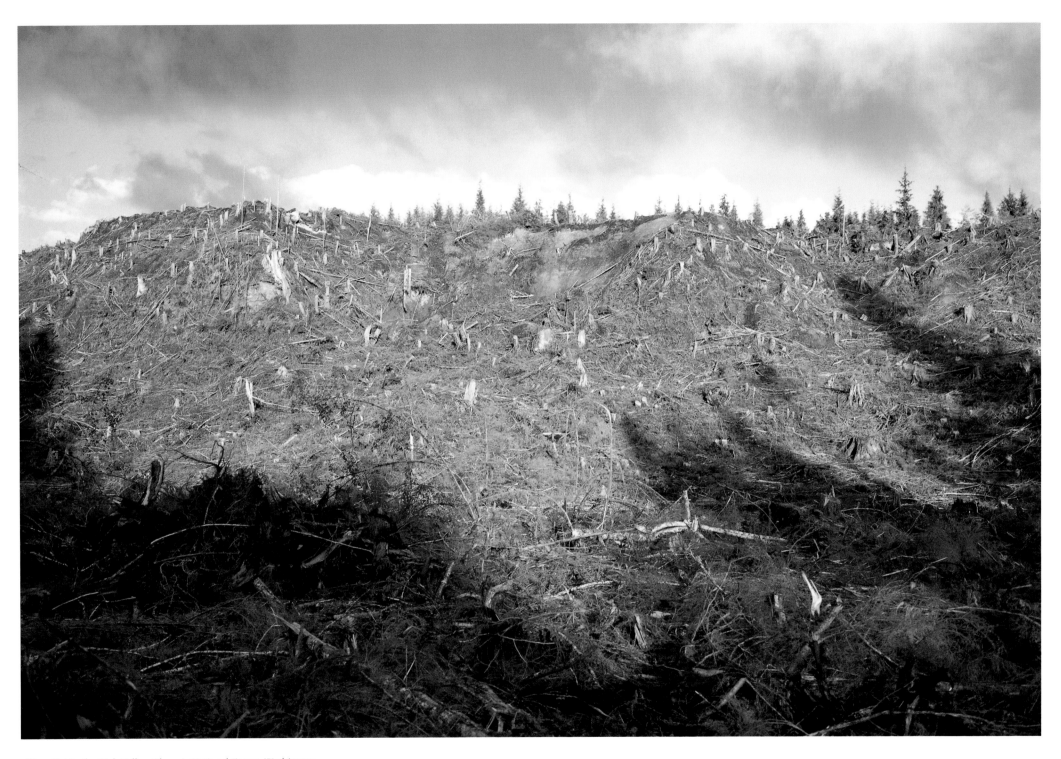

Clear Cut in the Hoh Valley, Olympic National Forest, Washington

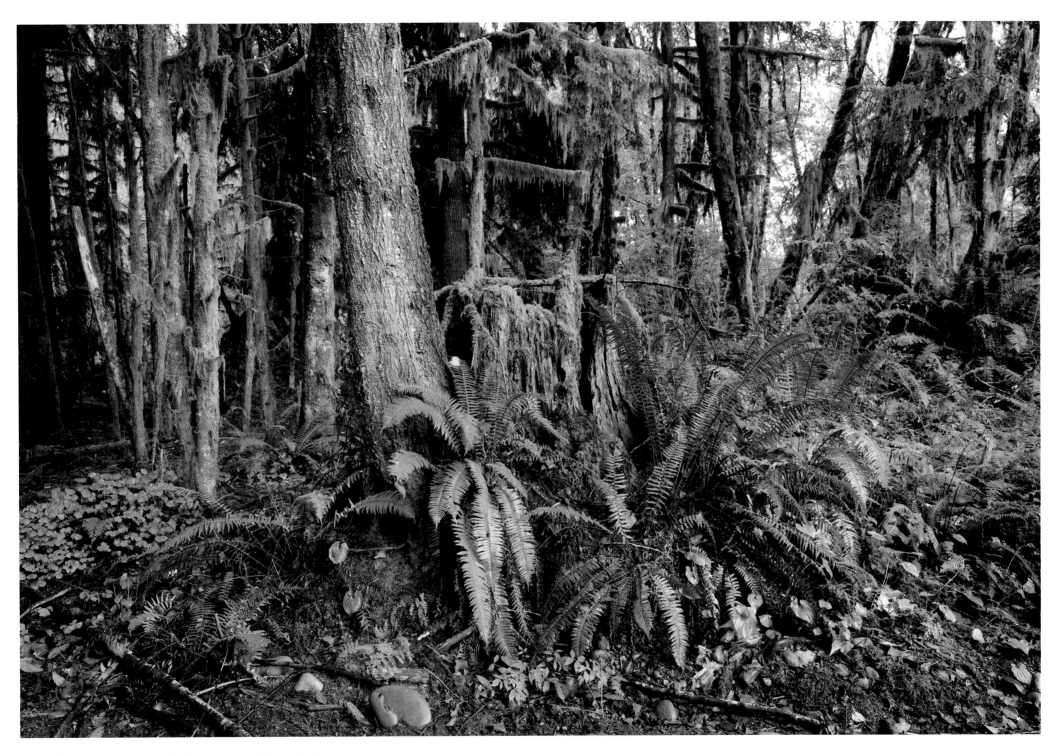

Hoh Valley Rain Forest, Logging in Olympic National Forest, Washington

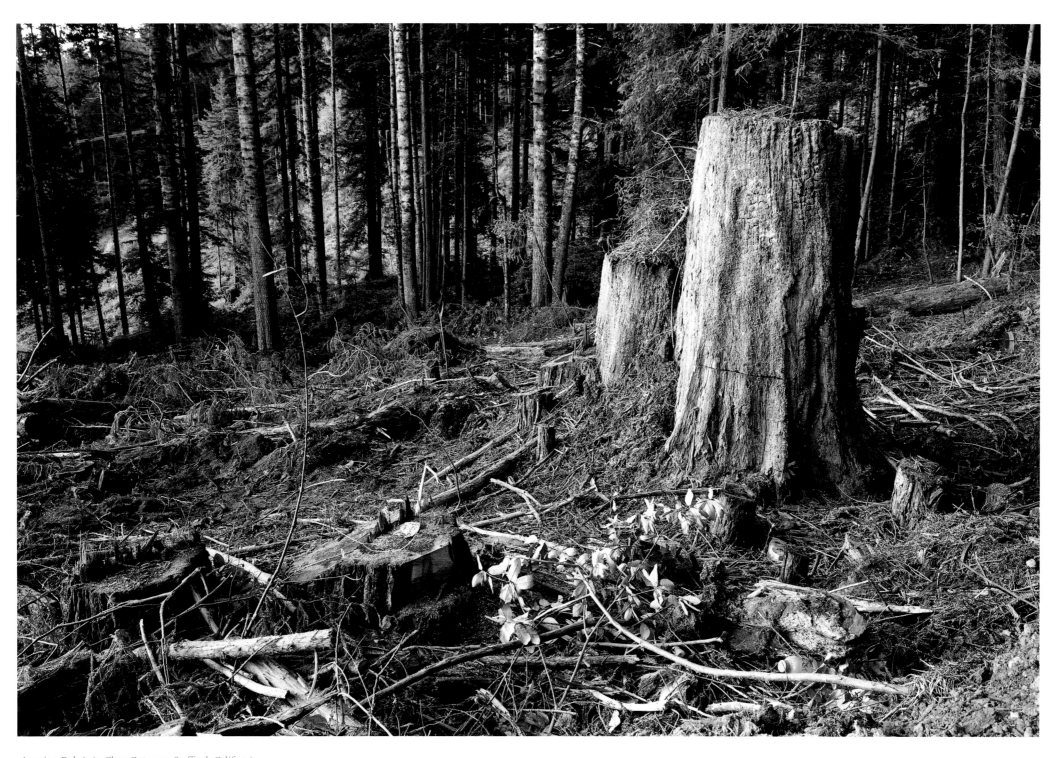

Logging Debris in Clear Cut, near Stafford, California

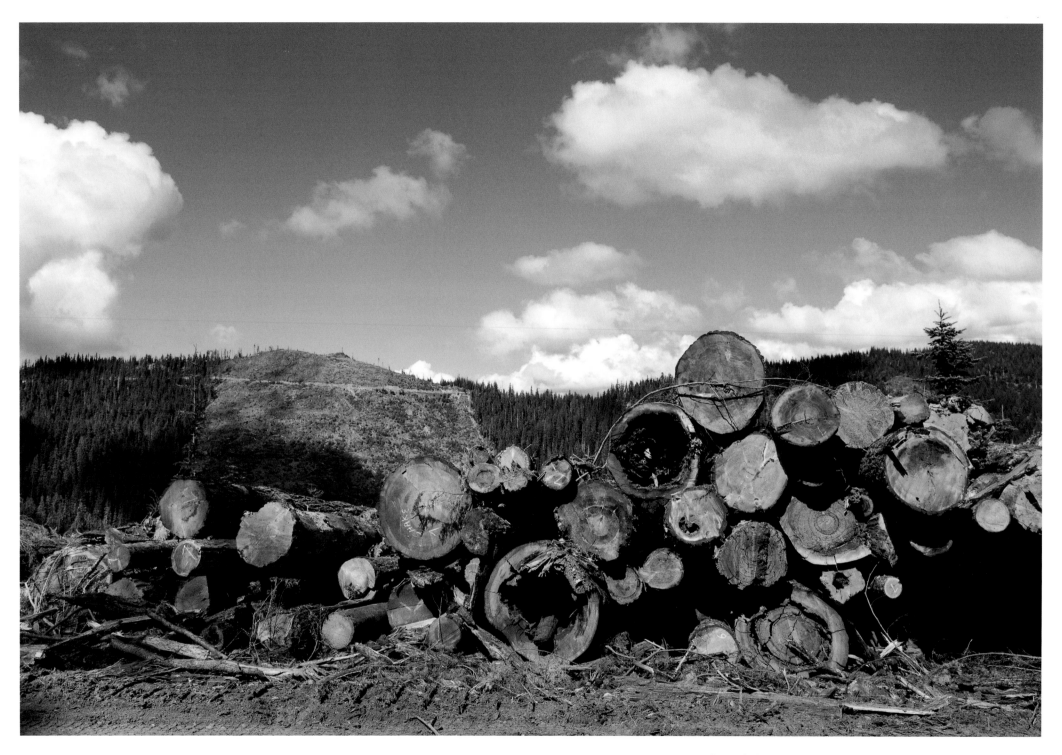

Log Landing and Clear Cut across a Mountain, Willamette National Forest, Oregon

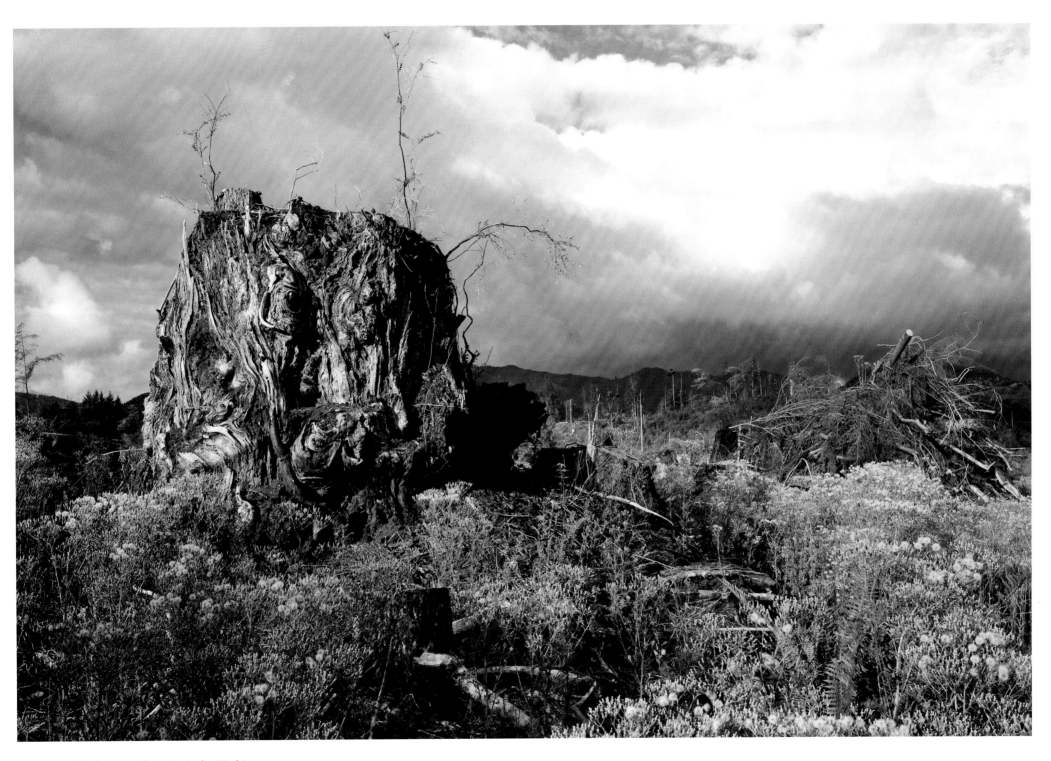

Mammoth Sitka Spruce in Clear Cut, Sapho, Washington

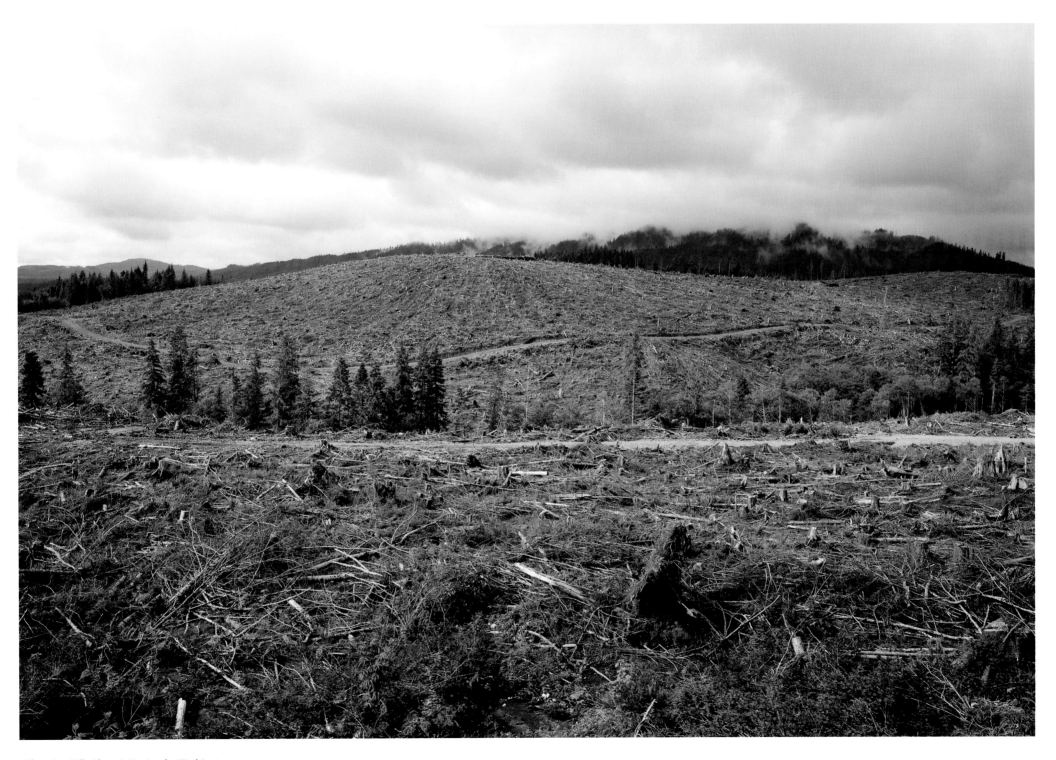

Clear Cut Hill, Olympic Peninsula, Washington

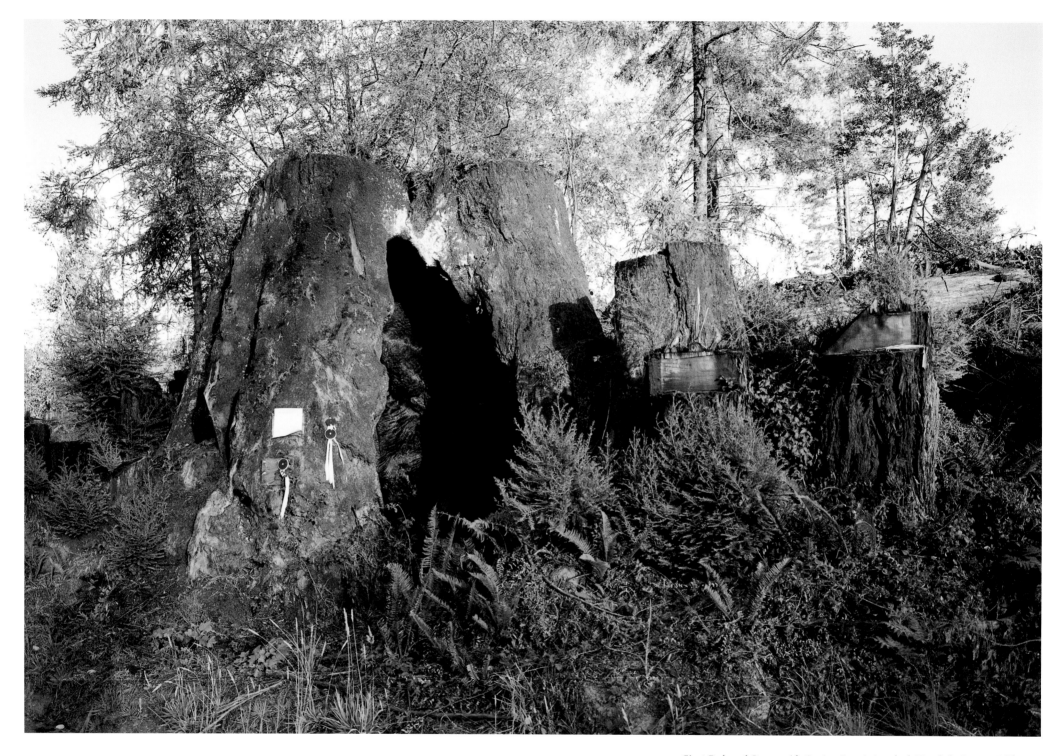

Giant Redwood Stump with Cutting Permit Attached, Humbolt County, California

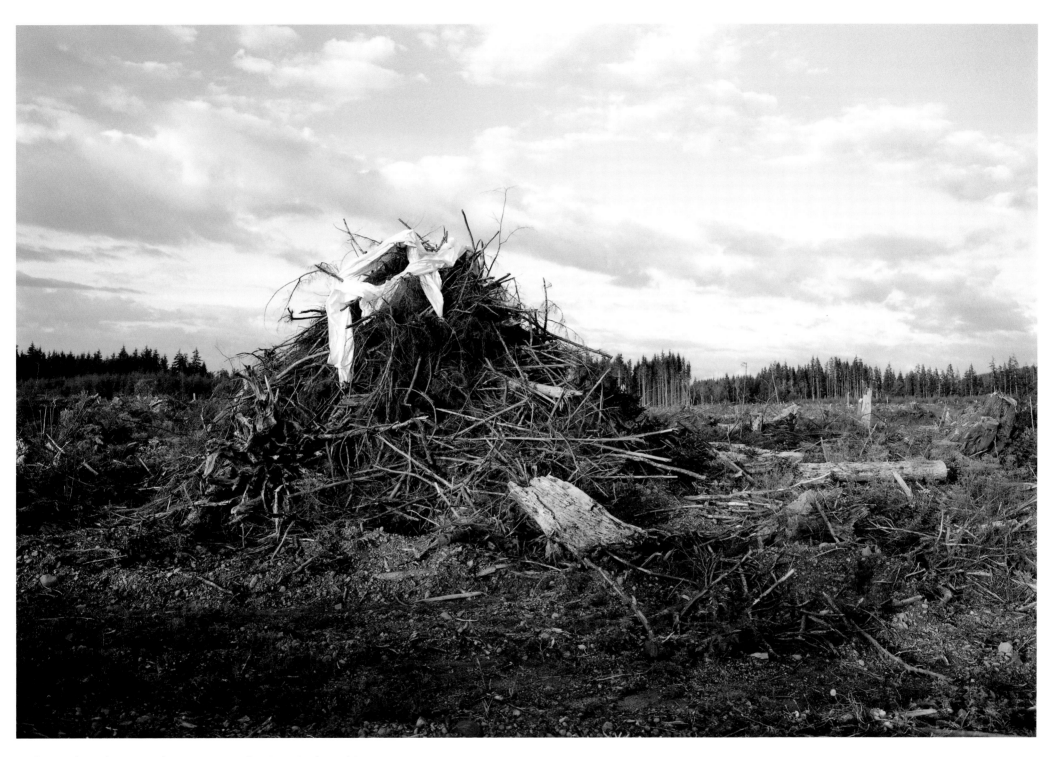

Cedar Branches and Logging Debris, Rain Forest, Olympic Peninsula, Washington

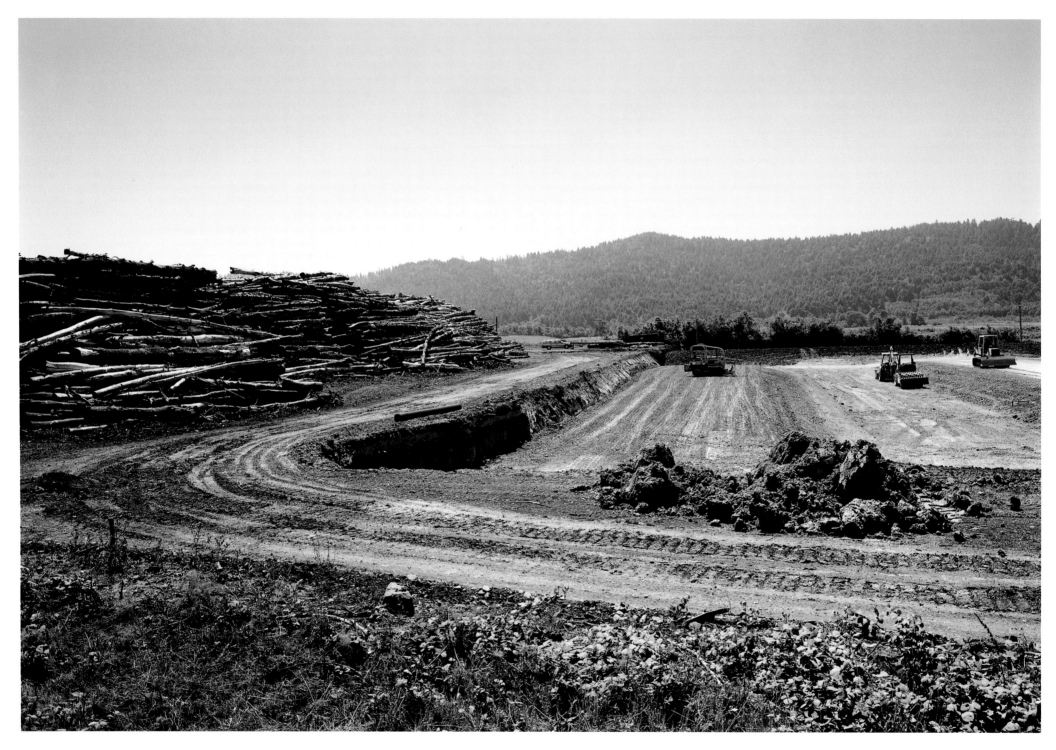

Lumber Mill Construction, Carlotta, California

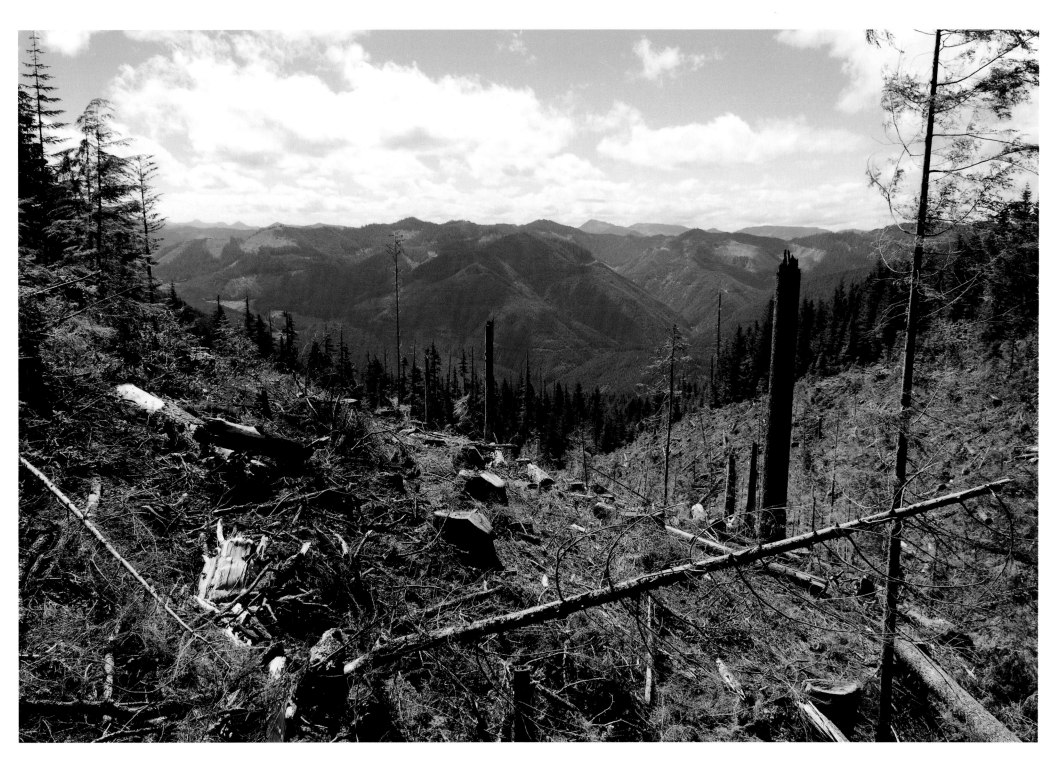

Site of a Federal Timber Sale, Willamette National Forest, California

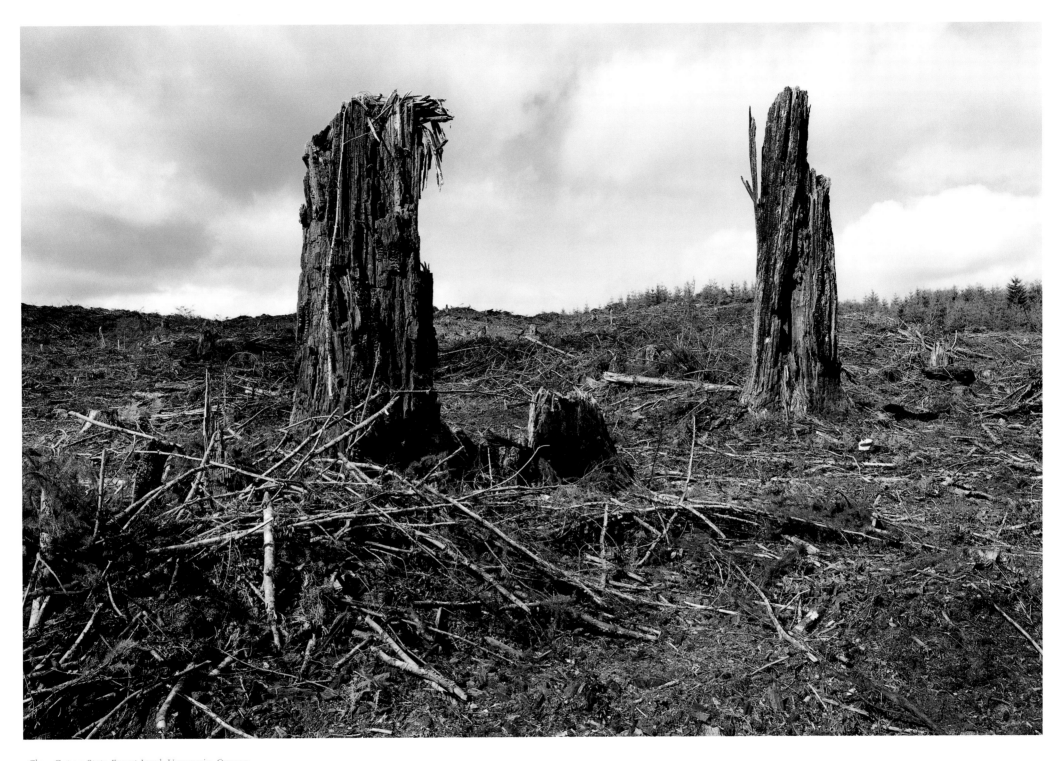

Clear Cut on State Forest Land, Vermonia, Oregon

The land is still
Only the ghosts gather in this graveyard
Of Indians, buffalo,
Small flowers that used to grow through stone
And the worn out women of the frontier

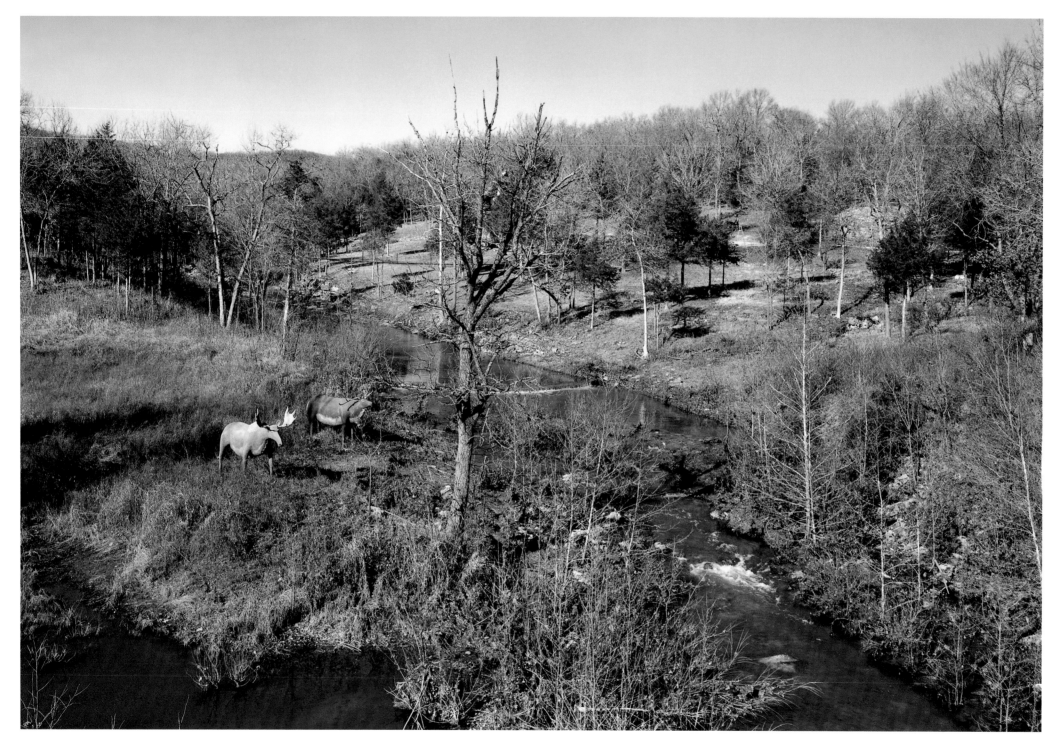

Cement Moose, Arkansas

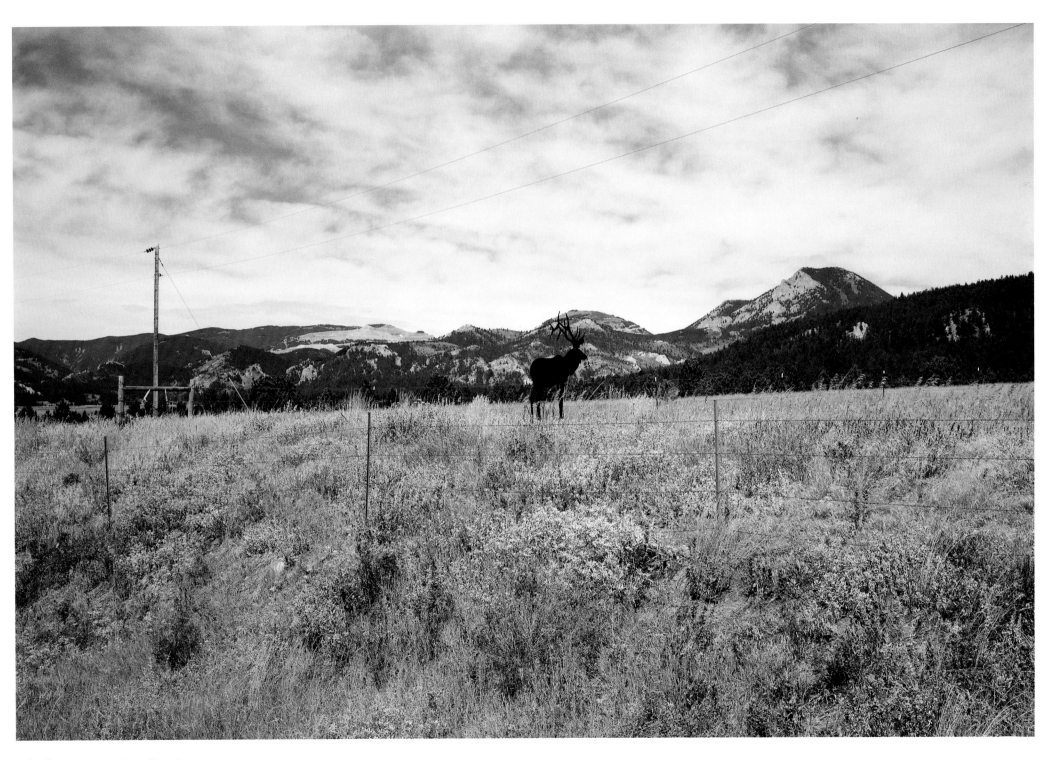

Elk Silhouette, near Jackson, Wyoming

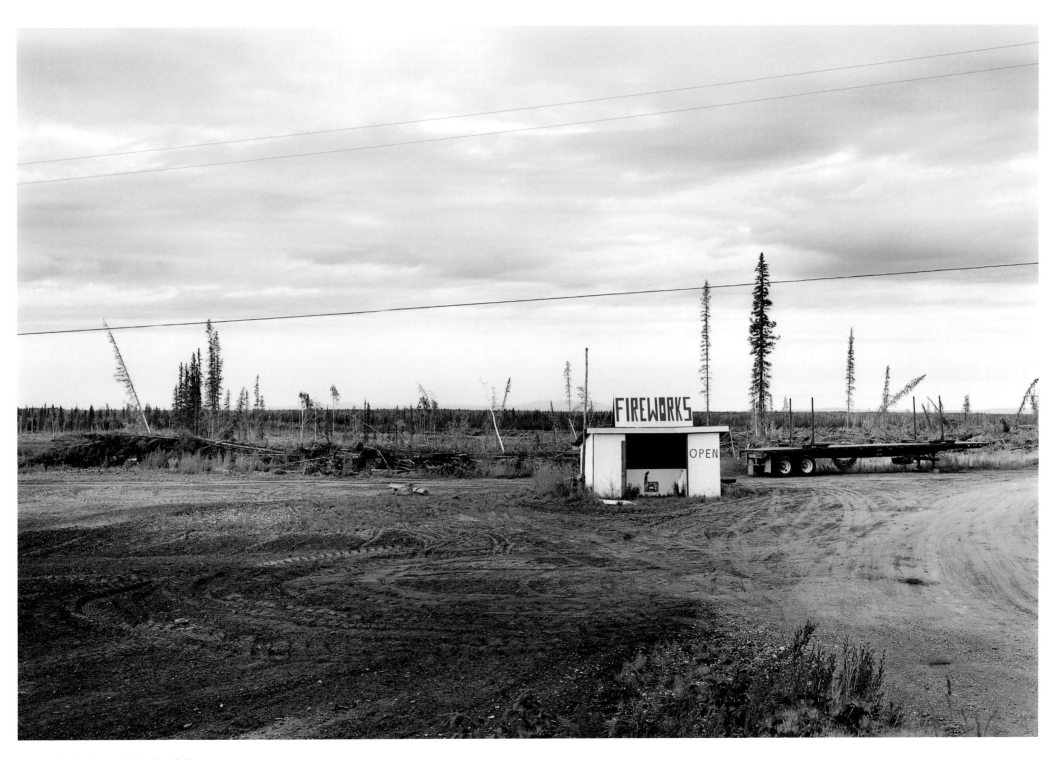

Fireworks Stand, near Fairbanks, Alaska

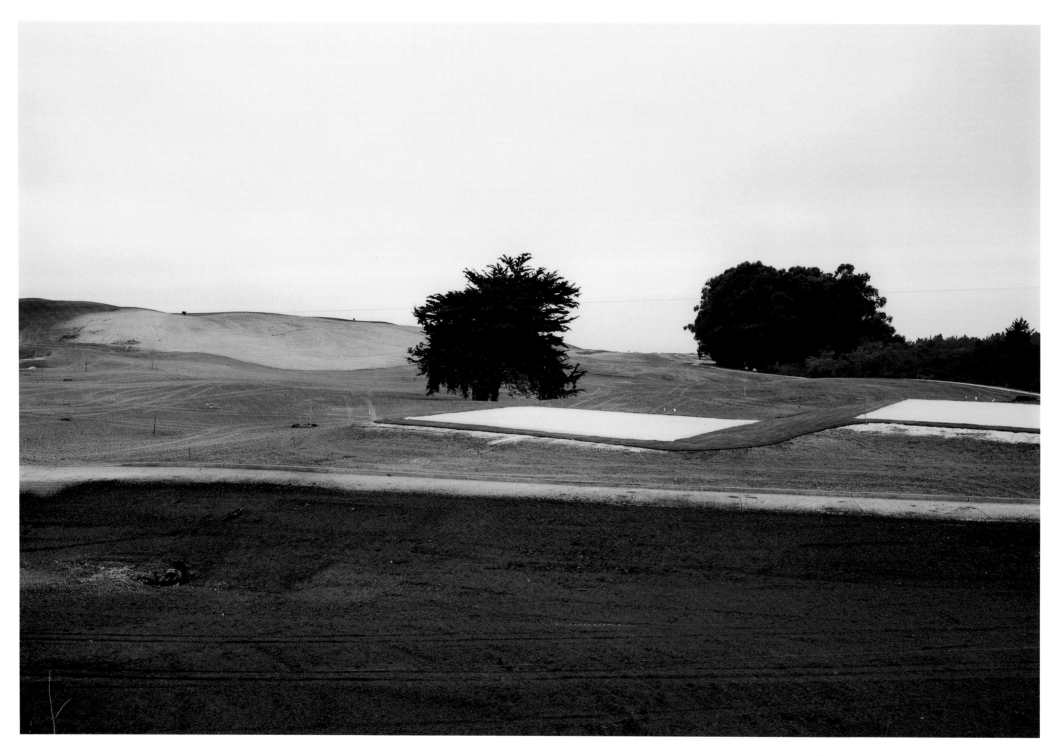

Golf Course Construction, Half Moon Bay, California

Connecting The Dots

It is hard not to feel a bit guilty when viewing John Ganis's remarkable photographs of the American landscape, but guilt is not supposed to be part of the American dream. Self-reliance, perhaps, certainly freedom, but not guilt. Guilt is more often a peculiar side-effect of certain brands of western religion.

In many parts of America, consumption has become a kind of religion, practised with great fervor. Expert economists and esteemed politicians tell us that "spending will get us out of the recession," the advertisers proclaim that "to save more you must buy more," and what was a luxury in the last generation is a necessity to most of us now. This pattern of consumption will go on endlessly, it seems, until there is a judgment day, either environmental or economic.

Most Americans pay little attention to their buying habits. They do not associate consumption with greed or guilt. Each one of us daily adds to the societal need to use and generate land in ways that John Ganis clearly points us toward. His landscapes are the results of our buying, spending, disposal, and waste. Are they beautiful and scenic? Are they useful and of lasting value? Like a national park? Like a well-tended garden? Like a public park? Like a place you would want to pass on to the next generation?

This interrogation is what photography can do for you. It can enlighten, inspire, inform, and disarm you with the truth. A truth that leads directly back to our needs. Need another computer because the current one isn't quite as fast as your competitor's? No problem, let's throw away the current one into a landfill and open up another mine; it only takes thirty different minerals to make a computer. Need a little more electricity to warm up or cool down that new home in the 'burbs? No problem, let's strip away a little more of that coal, and reclaim it if we can afford to. Need to add on to that 5,000-square-foot home that, all of a sudden, isn't quite big enough for the two of you? No problem, let's go get those nice big trees in the national forests. See how guilt can enter the picture like a flash of light?

After all, landscapes and places, as physical realities, do not lie. They lay before us as evidence of our deeds, our aspirations, our shortcomings. The landscapes and places in John Ganis's photographs tell us the oft-forgotten story that, until we connect the dots between our addiction to consumption and healing the landscapes of consumption, there is much to feel guilty about. Even those who adhere to the idea of an unspoiled creation know how difficult it is to be responsible for one's actions on Earth.

John Ganis did not seek out these landscapes of America, but they found him through his lens. They showed him that there is a direct relationship between one's lifestyle and one's national landscape, that every time you need something you can buy it, with cash or, better yet, on credit with low financing. The beauty of it all is that so few of us have to see, much less explain or rectify, the landscapes and places that John Ganis has found for us all to view, from sea to shining sea.

The images in this fine book should make us feel a bit guilty, a bit on edge, for we have not taken the time to realize how our very being affects the land itself. What John Ganis finds so discomforting is our apparent unwillingness to connect the dots, so that we might soon become better caretakers of the American landscape. If we are going to drive our S.U.V.s around and push urbanized society farther out into the countryside, then we should be willing to pay the price for mitigating the impact of our habits, to heal the land for the generations to come even as we strive to make an honest living.

America is as much about its diverse lands as it is about its multiple ideas; the two are inseparable and they provide us with hope that we can do better. And when we see images such as those in this book, they penetrate the heart, head, and soul with their unique blend of sorrow and aesthetic appeal. They direct us to overcome the guilt of seeing land mistreated in the interests of self-indulgence; they implore us to create better places in which to live, work, and explore. They instill in us the hope for a better life, and therein lies a dream that all Americans can embrace and be proud of.

George F. Thompson

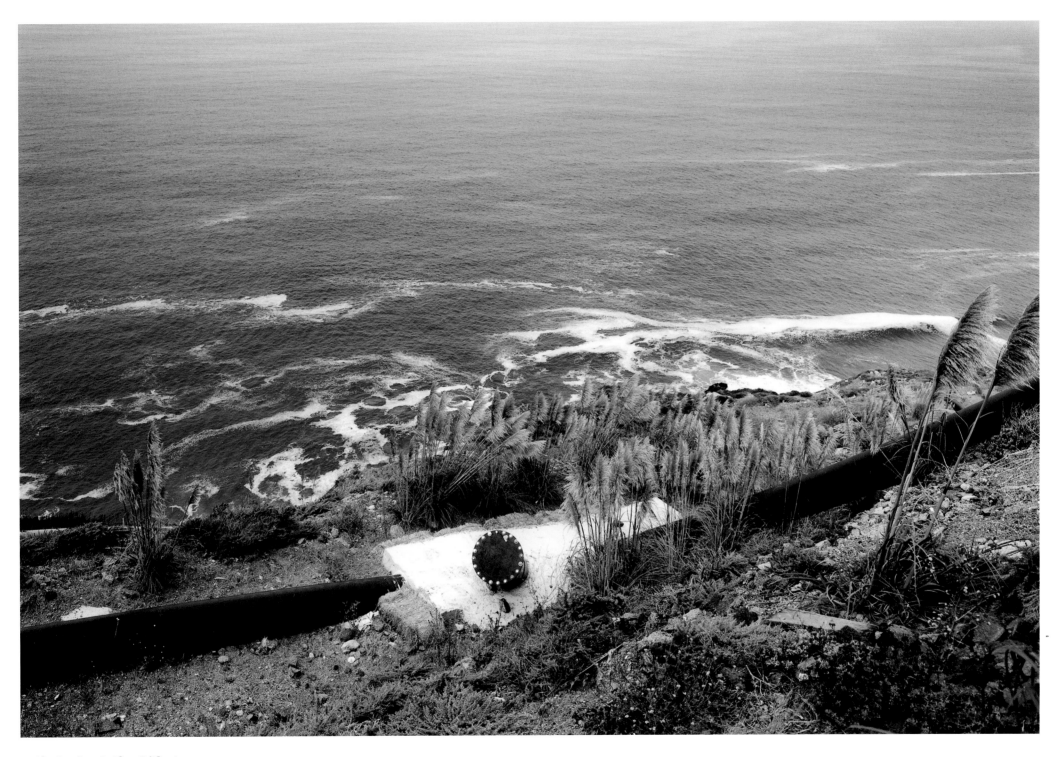

Pacific Coastline, Pacifica, California

During the last nineteen years I have traveled the United States making the photographs in this volume. The first image, taken in 1984, of an Earthmover in Texarkana kicking up a huge cloud of southern red soil, was made as I was returning from a retreat in Texas where I had undertaken an intensive meditation experience. I saw the site as I was driving along. For the next ten miles or so I was unable able to get the image out of my mind – the red earth, the isolated trees, the dust cloud. It had awakened in me a profound sense of empathy for the land that I had never experienced before. I turned around, drove back, and made the picture.

I see myself as a witness to the problems of land use, but it is the empathetic response to the land that I discovered in making that first picture which brings passion and purpose to my work. It is a synthesis of factual and metaphoric content. The factual content is conveyed through the lens-formed view of a world littered with the remains of man's enterprises, while metaphor initiates the process of rediscovering a reverence for the land that is often beautiful in spite of its distress. If reverence is still possible it must happen in a world of diminished purity. The dialectical processes involved in modes of production and resource development infuse the landscape with unexpected levels of interpretation that cause the viewer to reflect on the American legacy of consumption.

The American landscape is fertile ground for my photographic investigation of the land use issues facing our society today. The environmental impact of land use is a global issue and so I am very pleased that this book will be shared by both an American and a European audience. The American approach towards the land is often characterized by mindless development and exploitation of both public and private land for corporate profit. We are now aggressively exporting this consumerist attitude to the rest of the world.

Some may say that it is wrong to make aesthetically interesting photographs about such troubling subject matter. For myself, I feel that apprehending the beauty and complexity inherent in any situation is, at least to some extent, what making art is about. It is my hope that the ironic beauty that I find in the sites I photograph will create an opening for the viewer to discover the multiple layers of meaning inherent in the American landscape while maintaining a critical awareness of the environmental issues revealed.

John Ganis, Detroit, May 2003

First and foremost I would like to gratefully acknowledge the contribution of the late Dr. Stanley Diamond, distinguished Professor of Anthropology and the Humanities, and Poet in the University at The New Centre for Social Research. In the year prior to his death in 1991 he collaborated with me by writing a number of poems in response to my photographs. Stanley Diamond was a figure of promethean greatness whose poetry and anthropological writings on 'the primitive' inspired me. His poetry makes an essential contribution to this book.

I would also like to thank Robert Sobieszek, Chief Curator of Photography at the Los Angeles Museum of Art for his introductory essay and for his insightful understanding of the traditions and representations of the American Landscape; George Thompson, Director of the Center for American Places for his thoughtful afterword and for his significant feedback on the editing and the final sequencing of the book.

I am tremendously grateful to my two publishers – Günter Braus and Dewi Lewis who made this book possible; to the printers, Wachter; to the German translator; to my eco-philosophy teacher Dr. Henryk Skolimowski, Chair of Ecological Philosophy at Warsaw University, for his interest and encouragement and for his writings and teachings which have played an important role in my evolving understanding of ecological values; and to Larry Fink, my long time teacher, friend, and mentor, whose tough advice inspired me to make more and better pictures.

I would like to give a special thanks to Sandra Schemske, my lovely wife, whose intelligent and honest council and emotional support could always be counted on.

I would also like to thank several friends, all important mentors for me, Mary Virginia Swanson, Susan Lipper, Diana Gaston and William Messer; my many colleagues and friends from the Society for Photographic Education; and my students who have helped with various aspects of the project especially Charles Cloud, Derek Johnson, Michael Frank and Jennifer Keber.

Also my thanks to the grass roots activists in the many local chapters of the Sierra Club and other environmental organizations who provided important information on many sites that I photographed. In particular Clark Fenton, Beren Reeder and the Friends of the Humbolt.

Finally I want to sincerely thank Josephine Diamond for her support of the vision that Stanley Diamond and I shared.

With my deepest gratitude to all and The All!

Om Shanti!

John Ganis

First published in the UK in 2003 by
Dewi Lewis Publishing
8 Broomfield Road
Heaton Moor
Stockport SK4 4ND
+44 (0)161 442 9450

www.dewilewispublishing.com

The right of John Ganis to be identified as author
of this work has been asserted by him in accordance
with the Copyright, Designs and Patents Act 1988

Copyright ©2003
For the photographs: John Ganis
For the texts: Robert Sobieszek, George F. Thompson and
The Center for American Places, John Ganis
For the poems: Stanley Diamond
For this edition: Dewi Lewis Publishing

ISBN: 1-904587-00-3

Design & artwork production: Dewi Lewis Publishing
Print and colour separations: Wachter Gmbh

This book was made possible, in part, by support from the following organizations:

The Michigan Council for the Arts
(Creative Artist Grant 1989-90),
The College for Creative Studies
(Sabbaticals in 1988-89 & 1997),
The Fifty Crows International Fund for Documentary Photography
(Finalist 2003)